POSTCARD HISTORY SERIES

Miami Beach

IN VINTAGE POSTCARDS

D1603246

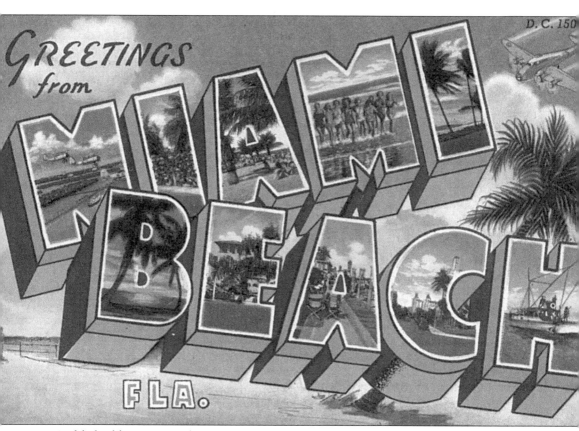

D. C. 150

Greetings from MIAMI BEACH FLA.

(Published by Curt Teich.)

POSTCARD HISTORY SERIES

Miami Beach

IN VINTAGE POSTCARDS

Patricia Kennedy

ARCADIA

Published by Arcadia Publishing,
an imprint of Tempus Publishing, Inc.
2 Cumberland Street
Charleston, SC 29401

Printed in Great Britain.

Library of Congress Catalog Card Number: 00-107239

For all general information contact Arcadia Publishing at:
Telephone 843-853-2070
Fax 843-853-0044
E-Mail sales@arcadiapublishing.com

For customer service and orders:
Toll-Free 1-888-313-2665

Visit us on the internet at http://www.arcadiapublishing.com

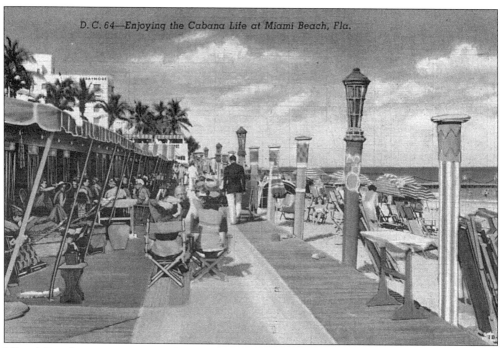

Miami Beach visitors enjoy a beautiful South Florida day at the oceanside cabanas in this 1941 postcard by Curt Teich and Co.

CONTENTS

ACKNOWLEDGMENTS

The images in this book are from my own collection with the exception of additional photographs that are acknowledged in the text. I wish to extend my gratitude to the following people who provided assistance, information, and photographs during the preparation of this book:

Sam J. Boldrick and Kenneth E. Koonce at the Miami-Dade Public Library; Clarece Depkin at Indian Creek Country Club; Deborah Gust and Christine Pyle at the Curt Teich Postcard Archives, Lake County Museum; Dawn Hugh at the Historical Museum of Southern Florida; Leslie Lawhon and Joan Morris at the Florida State Archives; Kathy Parkerson at St. Patrick's Church; Arno Weinstein and Ginger M. Young at the Jewish Museum of Florida; and a special thanks to my editor, Christine T. Riley.

INTRODUCTION

One could say that the development of Miami Beach as a popular resort was the result of three palm trees.

In 1868, Henry B. Lum was standing on the deck of a passing steamship from Havana, when he spotted three palm trees growing on the shoreline of the future Miami Beach and envisioned a coconut plantation. Lum returned in 1881 with a crew, purchased all the land south of today's Fourteenth Street from the state for 35¢ an acre, and began planting coconut trees. By 1885, Lum and his men gave up on the idea of establishing a coconut plantation, but they did leave a scattering of palms that had successfully taken root. The idea of Miami Beach as a potential agricultural site, however, soon spread. Ezra Osborn and Elnathan Field put together a group of investors who bought land north of Lum's plantation and planted nuts. One of those investors was New Jersey horticulturist John S. Collins, who had invested $5,000. When the railroad reached Miami in 1896, Collins came down to check on his investment. The Osborn and Field project also failed, but Collins bought out Osborn and tried planting 3,000 avocado trees on his land between Fourteenth and Sixty-seventh Streets. To protect his trees from the wind, Australian pines were planted along what is now Pine Tree Drive. Eventually, Collins also bought out Field and became the owner of 1,670 acres of oceanfront property. He was over 70 years of age when he decided to build a bridge to the mainland. His daughter Katherine and her husband, Thomas J. Pancoast, came down to see Collins's plan and also recognized the potential of the area. They decided to open their real estate to tourists. Collins invested $100,000 of his own money to build the wooden bridge connecting Miami Beach to the mainland.

In 1912, John and James Lummus purchased all of Henry Lum's property south of Lincoln Road and formed a development company called Ocean Beach. Meanwhile, Collins ran low on funds before his bridge was completed. At that point, Carl Fisher, who had made his fortune by inventing the first reliable headlight for automobiles, agreed to loan Collins $50,000 to complete the bridge. In return, Fisher received 200 acres of land. Fisher then loaned the Lummus brothers $150,000 in return for all the land from Lincoln Road to Fifteenth Street. Fisher and the Lummus brothers then worked together to dredge sand from Biscayne Bay. The dredging resulted in Carl Fisher paying millions of dollars to clear the mangroves and lay new sand on the beach. By the time the work was completed, there was relatively little vegetation remaining

except for the coconut trees from the earlier expeditions. To keep the new sand from blowing away, Fisher had grass planted, along with brilliantly colored hibiscus, oleander, and bougainvillea bushes. The former mangrove swamp had become a tropical garden.

As development continued, residents and tourists began visiting the beach by means of the Ocean Beach Ferry. Bathing pavilions called "casinos" were built to accommodate the increasing number of visitors. Dick Smith opened the first casino, a small structure with changing rooms and a refreshment stand. John Collins also built a casino in what was considered the northern part of the beach around Twenty-third Street. Collins's bridge opened on June 12, 1913, and Miami Beach was on its way. Carl Fisher called his development Alton Beach, the Lummus brothers development was called Ocean Beach, and Collins's real estate venture was named the Miami Beach Improvement Company. On March 26, 1915, the three developments were combined to create the city of Ocean Beach. The new city was incorporated with 300 residents and 33 registered voters. J.N. Lummus was elected as the first mayor. He soon changed the name of the main thoroughfare to Collins Avenue. A year later the city's name was changed to Miami Beach.

Visitors enjoyed the beach but no one was rushing to buy land. The Lummus brothers hired Edward "Doc" Dammer to sell their land, offering gifts as incentives. They encouraged Miami residents to build "beach homes." Fisher tried a different approach, promoting the city as a fashionable resort for the wealthy. He bought a billboard on New York City's Fifth Avenue and Forty-second Street that flashed this message during the winter: "It's June in Miami." It worked. By the 1920s, people were flocking to the new resort destination, and the city had its first building boom. Numerous hotels, both large and small, were built, as well as country clubs and lavish winter estates. The devastating hurricane of 1926, however, destroyed lives and property and ended the building boom. Tourists were just beginning to return in numbers in 1929 when the stock market crashed. The city struggled for a while, but its beautiful tropical climate still offered an escape from the Northern winter cold, and the legalization of parimutuel betting offered extra enticement. By 1933, the beach was on its way to recovery.

The 1930s and 1940s brought another building boom. The influx of tourists and new residents required more hotels and apartments. The population of Miami Beach had increased tenfold from 1920 to 1930. The structures built in the 1930s and early 1940s took on a new appearance. The 1925 Paris Exposition Internationale des Arts Decoratifs et Industriels Modernes influenced a new style of architecture simply called Moderne at the time. Eventually the term Art Deco was used to describe this architectural style that incorporated sleek, streamlined elements made popular by industrial designers. The structures reflected the aerodynamic designs of the ocean liners and trains. Nautical influences, geometric shapes, Egyptian motifs, and the flowery shapes of Art Nouveau were combined, creating a lighthearted, whimsical atmosphere that lifted the mood of the time. The strong influence of the seashore and tropical images led to the evolution of the "Nautical Deco" and "Tropical Deco" styles, which embraced the natural beauty of Miami Beach.

The area known as the Miami Beach Art Deco Historic District contains the largest concentration of Art Deco buildings in the world. The area has enjoyed a rebirth with the renewed appreciation of its architectural treasures. Once again, as in the postcards shown in this book, the sidewalk cafés are filled, visitors and residents stroll along the oceanside, and the neon lights of Ocean Drive beckon in the night sky. Many of these Art Deco gems are shown in this book, which also features Miami Beach in its entirety, from South Beach to the northern areas of Surfside, Bal Harbour, and Sunny Isles.

One

THE CREATION OF

A RESORT

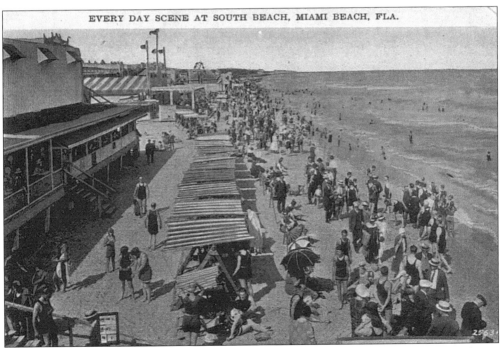

South Beach has offered fun in the sun for a long time. This *c.* 1920 postcard shows visitors enjoying the oceanside activities in front of the casino, a term which, at the time, simply meant "bathing pavilion." Admission was a nickel, and bathing suits could be rented for a quarter. (Published by J.N. Chamberlain.)

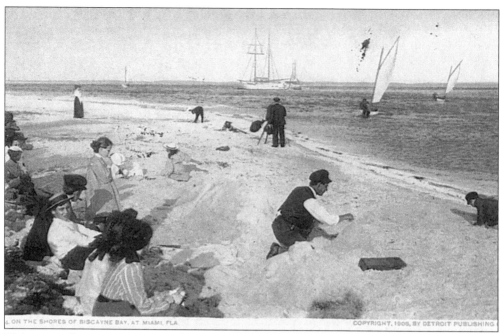

Visitors to the Miami area could choose, as they can today, from a variety of beaches along Biscayne Bay or the Atlantic Ocean. The sunny shores and warm tropical waters of Biscayne Bay provided the perfect setting for an outing on this beautiful day in 1905. (Published by Detroit Publishing Co.)

The earliest casino on Miami Beach was opened by Dick Smith. Shown in this *c.* 1910 photograph, it had a refreshment stand and a small dance floor, making it South Beach's first nightclub. Joe Weiss, who would later open Joe's Stone Crab Restaurant, had a sandwich stand at the casino. (Courtesy of Florida State Archives.)

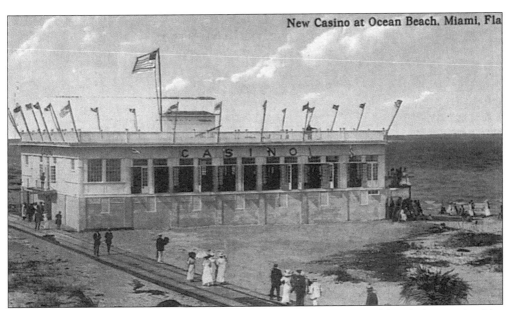

Before the opening of John Collins's bridge, "Ocean Beach" could only be reached by ferry or private boat. Round-trip tickets on the *Lady Lou* or *Sally* sold for 20¢. The beach visitors shown here are on their way to the Ocean Beach Casino, where the flags of various nations flew from the top deck and the American flag flew in the center of them all. (Published by J.N. Chamberlain.)

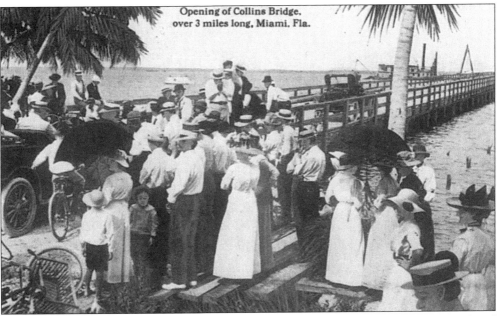

Crowds celebrate the opening of the Collins Bridge in 1913. The bridge, considered the world's longest wooden bridge at the time, reached from the mainland to Bull Island, today's Bell Island. From there, early visitors used a footbridge from the island to the beach. Collins Bridge was replaced by the Venetian Causeway in 1925. (Courtesy of Florida State Archives.)

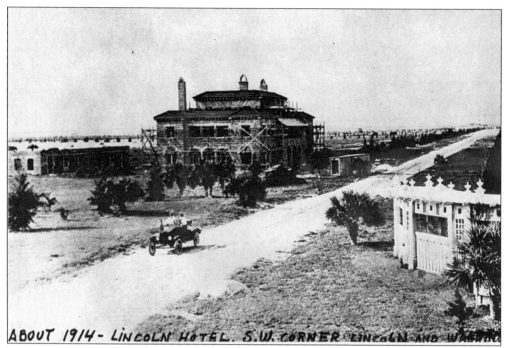

ABOUT 1914 - LINCOLN HOTEL. S.W. CORNER LINCOLN AND WASHIN

Carl Fisher built Lincoln Road and named it in honor of his idol, Abraham Lincoln. This *c.* 1914 photograph shows the Lincoln Hotel, which Fisher built on the southwest corner of Lincoln Road and Washington Avenue. (Courtesy of Florida State Archives.)

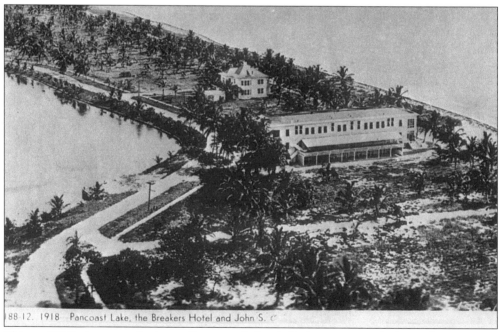

88-12. 1918 Pancoast Lake, the Breakers Hotel and John S. C

This *c.* 1918 photograph shows Pancoast Lake (which was named after John Collins's son-in-law Thomas Pancoast), the Breakers Hotel, and the home of John S. Collins. (Courtesy of Florida State Archives.)

12

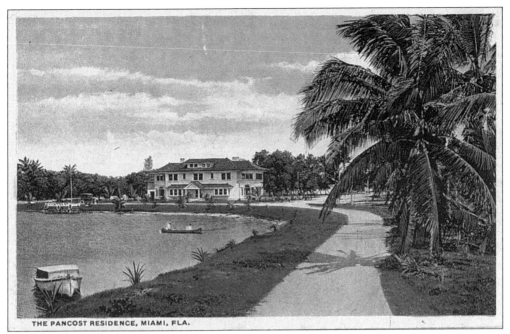

THE PANCOST RESIDENCE, MIAMI, FLA.

Thomas Pancoast built the first concrete house in Miami Beach on the northeastern shore of Lake Pancoast. The lake was originally known as "Indian Lake" and was occupied by crocodiles. Between the noise of the dredging and the filling in of the shoreline, the native salt-water crocodiles abandoned the lake. Later, swans were brought in, creating a friendlier environment. (Published by H. & W.B. Drew Co.)

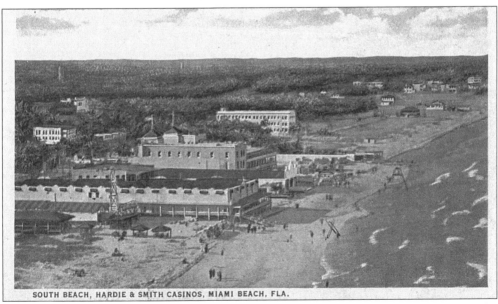

SOUTH BEACH, HARDIE & SMITH CASINOS, MIAMI BEACH, FLA.

This *c.* 1920 view of South Beach shows the Hardie and Smith Casinos. Dan Hardie served as sheriff in the early days of Miami and ran his casino as a good family place. Avery C. Smith improved the earlier casino of Dick Smith (no relation) by adding a large salt-water pool and better dressing rooms. (Published by Curt Teich.)

13

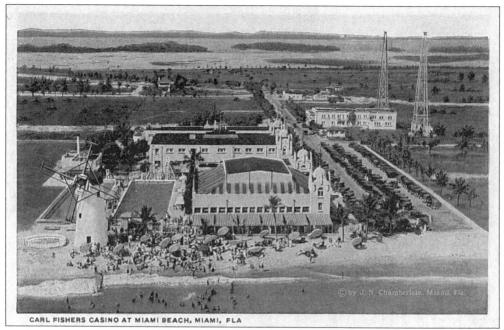

CARL FISHERS CASINO AT MIAMI BEACH, MIAMI, FLA

Carl Fisher bought John Collins's North Beach Casino, located at Twenty-third Street in what was considered the northern end of the beach at the time. Fisher refurbished the casino and renamed it the Roman Pools. The Marconi Wireless Towers, shown on the right, were put up in 1914 by the United States government during its first attempts at ship-to-shore communication. (Published by J.N.Chamberlain.)

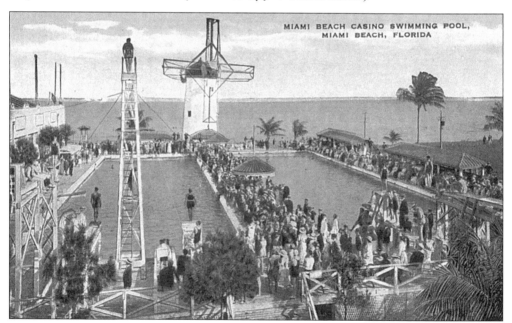

MIAMI BEACH CASINO SWIMMING POOL, MIAMI BEACH, FLORIDA

A Dutch windmill was a popular landmark that pumped salt water into two large swimming pools, where diving and swimming exhibitions drew large crowds. (Published by Pictorial Center.)

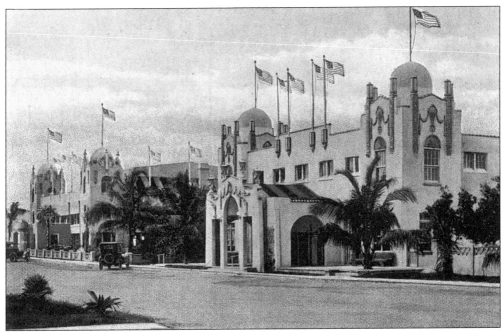

This *c.* 1920 photograph shows the entrance to the Roman Pools. The popular recreational facility clearly shows the strong Mediterranean influence on early South Florida's architecture. (Courtesy of Florida State Archives.)

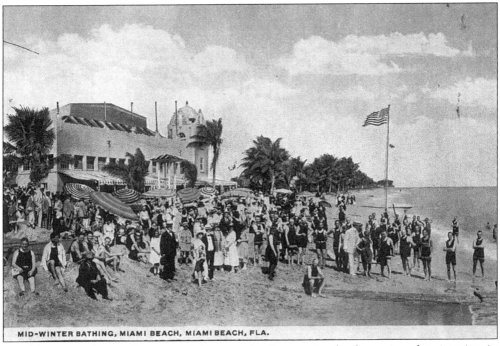

MID-WINTER BATHING, MIAMI BEACH, MIAMI BEACH, FLA.

In addition to the pools, many visitors to the Roman Pools also enjoyed swimming in the surf of the Atlantic Ocean. It was not unusual at that time for people to enjoy the ocean while sitting fully clothed on the sand. (Courtesy of Florida State Archives.)

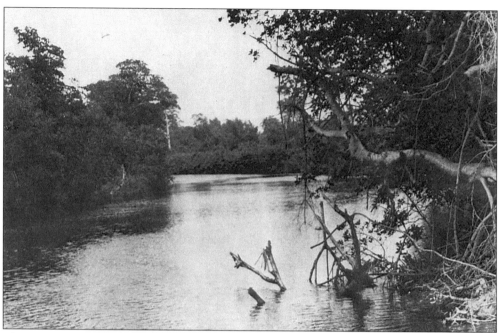

This 1919 photograph shows Indian Creek, located a few blocks north of Lake Pancoast. This is what the entire area looked like before workers began the formidable task of clearing the mangroves and depositing sand dredged from the bottom of Biscayne Bay. (Courtesy of Florida State Archives.)

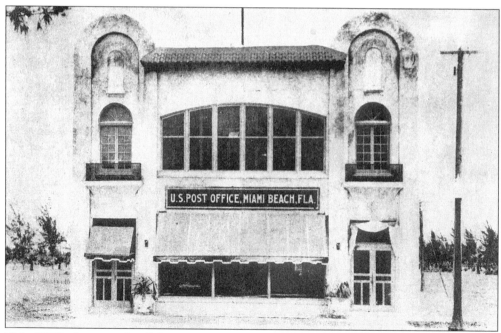

This 1920 photograph of the Miami Beach Post Office at Fifth Street and Alton Road reflects a growing population and the increasing importance of the new city. (Courtesy of Florida State Archives.)

Carl Fisher built the Lincoln Plaza at Eighth Street and Lincoln Road in 1924. The building continued to be utilized in various capacities over the next 70 years until 1994, when it was completely renovated and restored as the Van Dyke Hotel and Café. (Courtesy of Florida State Archives.)

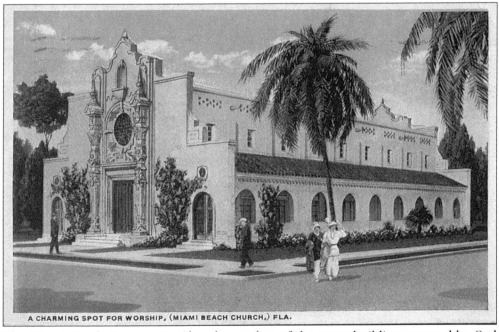

A CHARMING SPOT FOR WORSHIP, (MIAMI BEACH CHURCH,) FLA.

The Miami Beach Community Church, another of the many buildings erected by Carl Fisher, is located at 500 Lincoln Road. Architect Walter C. DeGarmo designed the Spanish Colonial Revival–style church in 1921. (Published by J.N. Chamberlain.)

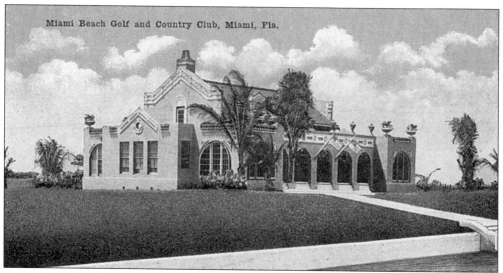

The Miami Beach Municipal Golf and Country Club, designed by August Geiger in 1916, is the oldest building in the Miami Beach National Historic District. Carl Fisher built this clubhouse for the players on his new golf course. President-elect Warren Harding played golf on the course in 1921. As a publicity stunt, Carl Fisher's pet baby elephant, Carl II, acted as caddy and carried the future President's golf clubs. The clubhouse received an award-winning restoration and is now the Washington Avenue Community Center. (Published by E.C. Kropp Co.)

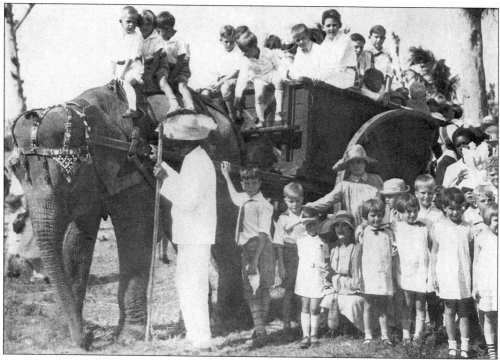

Carl II is shown here giving children a ride to the Egg Hunt at the Miami Beach Country Club in the early 1920s. (Courtesy of Florida State Archives.)

18

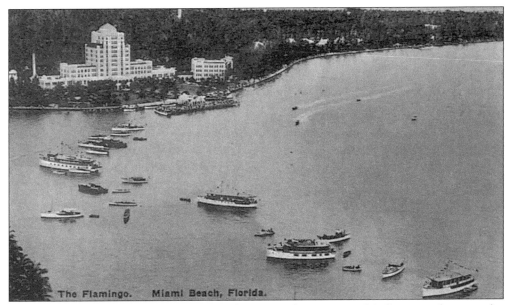

The Flamingo. Miami Beach, Florida.

Carl Fisher and his partner Cecil G. Fowler opened Miami Beach's first grand resort, the Flamingo Hotel, on New Year's Day in 1921. The $2-million, 150-room hotel overlooked Biscayne Bay. The glass dome on the rooftop (which made the 154-foot building the tallest building south of Jacksonville) was illuminated at night in red, green, and gold. (Published by Albertype Co.)

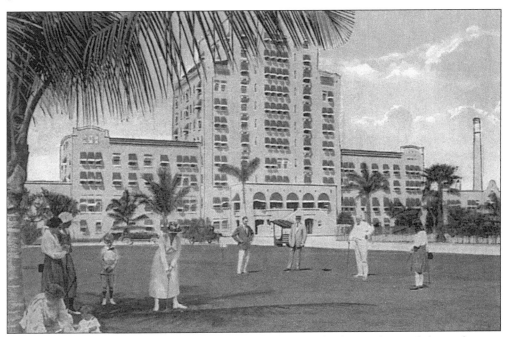

The Flamingo offered yachting, swimming, a private dock, a cabana club, and many other activities. The hotel was set on 15 acres of flowering gardens. This postcard shows a family enjoying a game of croquet while the baby and grandmother sit under a palm tree. (Published by Curt Teich.)

19

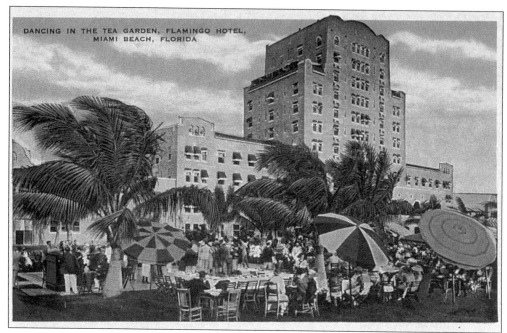

Large multi-colored umbrellas and palm trees offered shade as guests socialized and danced in the tea garden at the Flamingo Hotel. The recreation grounds of the hotel would later become the site of a central city park called Flamingo Park. (Published by E.C. Kropp Co.)

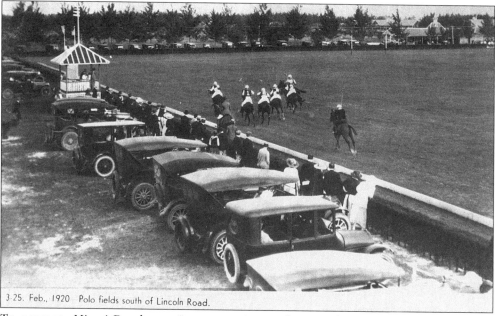

To promote Miami Beach as a "sportsman's paradise," Fisher introduced polo to the city in 1919. Spectators line the field in this 1920 photograph, which reflects the growing popularity of this fast-paced and colorful sport. The polo field occupied most of today's Flamingo Park. (Courtesy of Florida State Archives.)

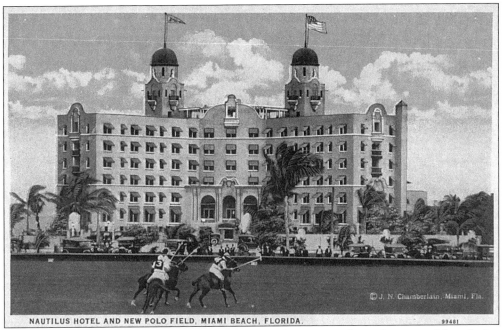

NAUTILUS HOTEL AND NEW POLO FIELD, MIAMI BEACH, FLORIDA.

Seeing the need for more hotel rooms, Carl Fisher opened another grand hotel, the Nautilus, in 1923. Shown above, polo players make use of the new polo field directly in front of the hotel. (Published by J.N. Chamberlain.)

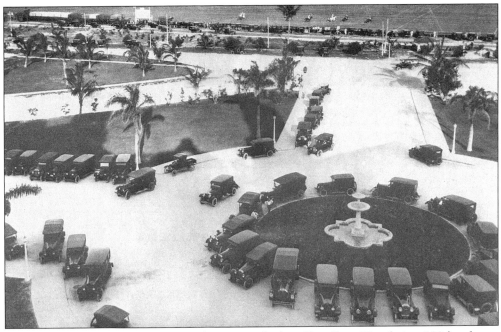

This photograph, taken from the top of the Nautilus Hotel in 1924, shows early taxicab drivers "staged" at the entrance of the hotel, awaiting their next passengers. Players on the polo field can be seen in the distance. (Courtesy of Florida State Archives.)

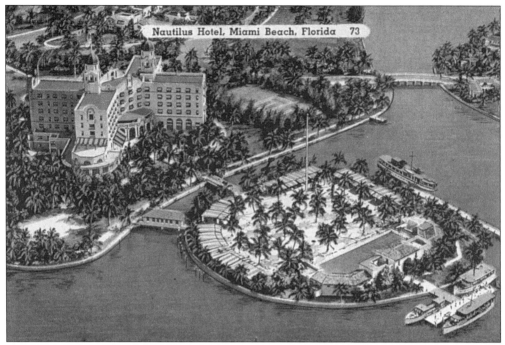

The four wings of the Nautilus Hotel took the shape of a Greek cross. This aerial view, taken in the 1930s, shows the island area, which contained the private beach, cabanas, swimming pool, and docks. (Published by Tichnor Bros.)

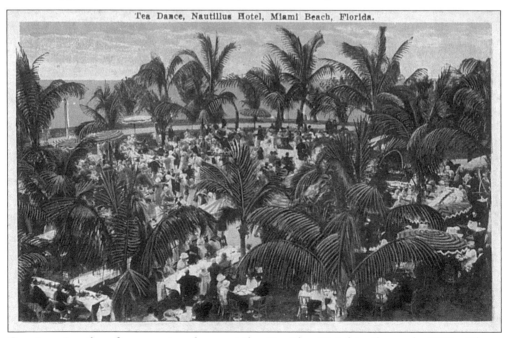

Tea Dance, Nautillus Hotel, Miami Beach, Florida.

Guests enjoy the afternoon tea dance at the Nautilus Hotel in the early 1920s. These dances were extremely popular and many other hotels offered them as well. (Published by E.C. Kropp Co.)

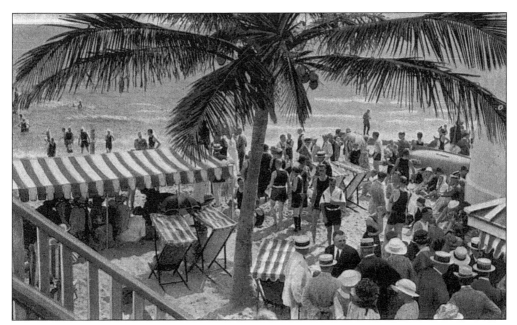

Sunshine, palm trees, and warm ocean waters symbolized Miami to those seeking escape from the rigors of Northern winters. In this early 1920s view, visitors enjoy a beautiful day on the beach in front of the Roman Pools. The rounded base of the windmill can be seen to the right. (Publisher not noted.)

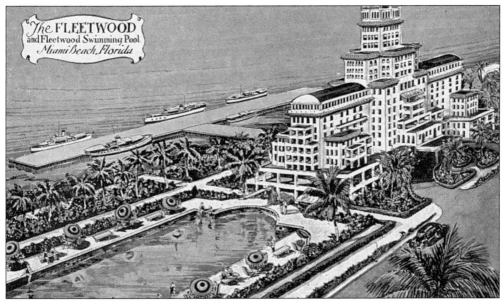

The Fleetwood Hotel, also located on Biscayne Bay, gave the Flamingo and Nautilus Hotels competition. The hotel boasted accommodations for 700 guests, a 230-foot dance floor, and a rooftop garden that could seat 800. Radio station WMBF, "Wonderful Miami Beach Florida," the most powerful radio station in the country at the time, broadcast from the hotel. Jesse Jay, who installed the station, would later establish WIOD, "Wonderful Isle of Dreams." (Published by Lumitone.)

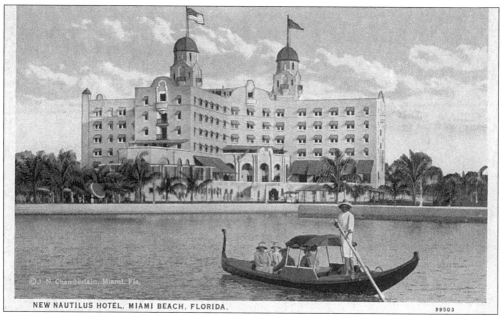

NEW NAUTILUS HOTEL, MIAMI BEACH, FLORIDA.

99503

While visiting Italy, Jane Fisher sent her husband, Carl, a gondola from Venice, giving him the idea to spend $4,000 having his boat builders make copies. Soon, hotel guests were enjoying piloted journeys on Biscayne Bay. (Published by J.N. Chamberlain.)

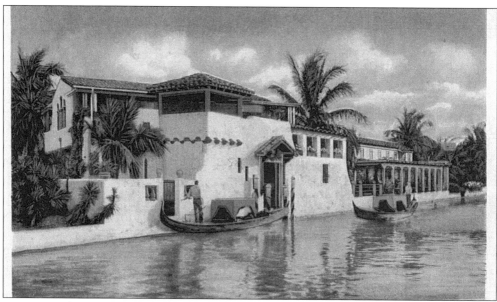

Miami Beach enjoyed the Venetian touch. Shown above is the residence and studio of artist Henry Salem Hubbell on the Dade Canal with gondolas moored outside. Hubbell painted portraits for wealthy vacationers. His home, at Michigan Avenue, was designed in 1925 by architects Schultze and Weaver, who also designed the Miami Biltmore Hotel and the Roney Plaza. (Published by Curt Teich.)

A lovely Mediterranean-style home on the canal creates "a bit of Venice in Miami Beach." (Published by Asheville Postcard Co.)

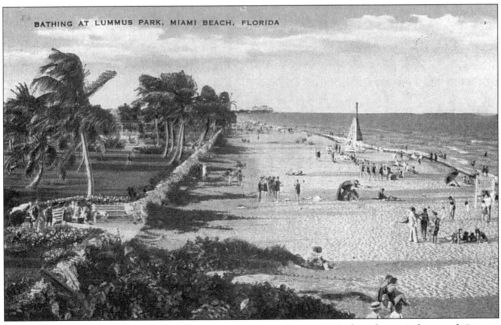

BATHING AT LUMMUS PARK, MIAMI BEACH, FLORIDA

After the city of Miami Beach was incorporated in 1915, brothers John and James Lummus sold 200 acres of their beach property to the city for $40,000 for use as a park. Shown above is Lummus Park, which remains a popular rest and recreational spot today. (Published by Pictorial Center.)

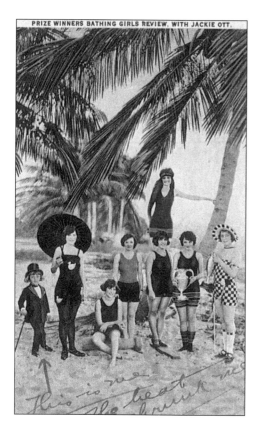

PRIZE WINNERS BATHING GIRLS REVIEW, WITH JACKIE OTT.

The prize winners in a Bathing Girls Review pose with Jackie Ott in this *c.* 1920 postcard. The lovely winner holding the trophy is wearing the height of fashion—a bathing suit and matching socks. (Published by J.N. Chamberlain.)

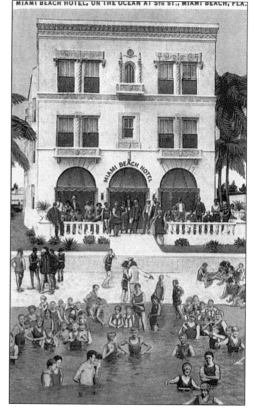

MIAMI BEACH HOTEL, ON THE OCEAN AT 5TH ST., MIAMI BEACH, FLA.

As the popularity of Miami Beach grew, the number of hotels, both large and small, grew with it. By 1925, the city had 33 hotels, 80 apartment buildings, and hundreds of private homes. Vacationers frolic in the ocean in front of the Miami Beach Hotel at Fifth Street. (Published by Curt Teich.)

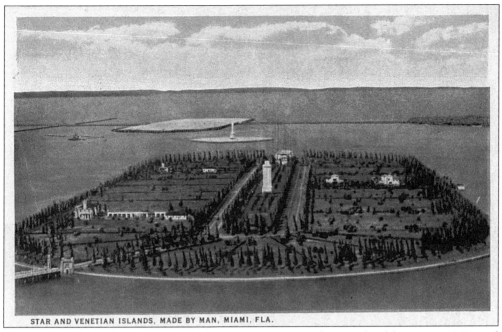

Carl Fisher and his Miami Ocean View partners created Star Island between 1917 and 1918 by dredging the bottom of Biscayne Bay. It was the first of a number of man-made islands that were later developed. Fisher's monument to Henry Flagler can be seen on the small un-landscaped island located in the distance. (Published by Curt Teich.)

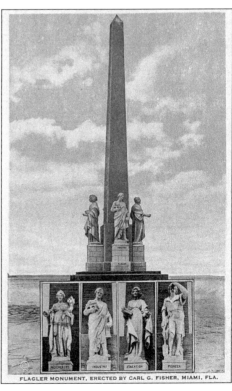

This close-up of Carl Fisher's monument to Henry Flagler shows figures representing "Prosperity," "Industry," "Education," and the "Pioneer" that encircle the base of the statue. The monument can be seen from the Venetian Causeway. (Published by J.N. Chamberlain.)

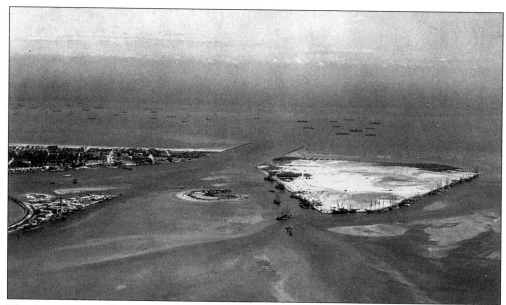

The Army Corps of Engineers began construction of Government Cut in 1902. The 700-foot-wide channel was cut through the southern end of Miami Beach, resulting in the severed tip becoming Fisher Island. Completion of the channel in 1905 gave Miami a deep-water channel to the sea. In the 1920s, the channel was dredged to a greater depth of 26 feet, which made the Miami Harbor accessible to larger cruise ships. Today, the Port of Miami is the busiest cruise port in the world. This aerial view was taken in 1918 during World War I. (Courtesy of Florida State Archives.)

Carl Fisher gave Fisher Island to William Vanderbilt in exchange for the Vanderbilt yacht, *The Eagle*. Vanderbilt constructed a winter estate that is now part of the Fisher Island Resort. Shown above is the main house of the former Vanderbilt estate. Today the mansion houses the formal dining rooms and lounge of the Fisher Island Club. (Courtesy of Florida State Archives.)

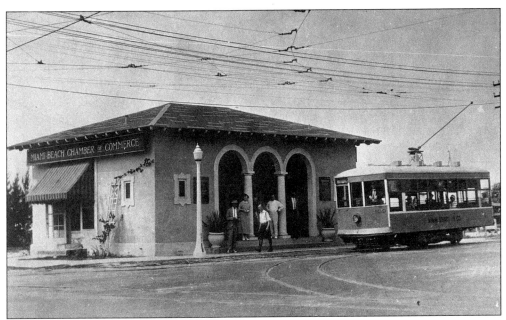

Construction began on the County Causeway (today's MacArthur Causeway) in 1917. When it was completed, Carl Fisher built a trolley line across the new Causeway transporting people between Miami Beach and Miami for a nickel. This 1921 photograph shows Trolley Car 109 eastbound at the foot of the Causeway at Fifth Street. The trolley is stopped in front of the first Miami Chamber of Commerce building. Thomas J. Pancoast was the president of the organization when it was formed in 1921. (Courtesy of Florida State Archives.)

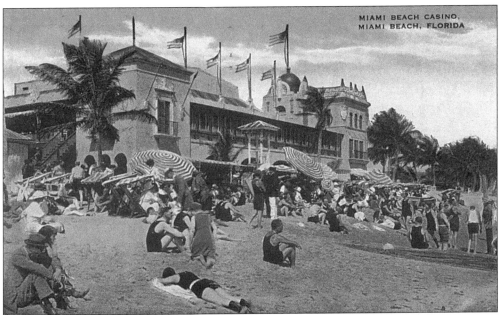

Sunbathers enjoy the tropical warmth and ocean breeze in front of the Roman Pools in this *c.* 1920 postcard. (Published by Pictorial Center.)

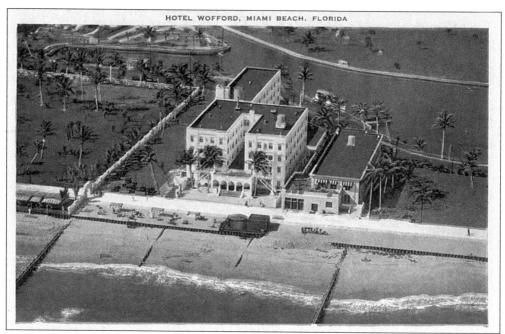

The Wofford Hotel, located a few blocks north of the Roman Pools, opened in time for the 1922 season. Within a few years, guests could walk along the promenade that ran in front of the Wofford, Pancoast, and Roney Plaza Hotels. (Published by E.C. Kropp.)

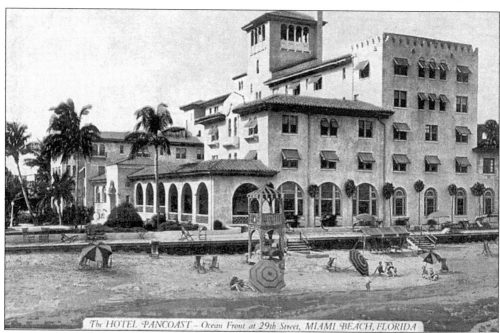

The HOTEL PANCOAST – Ocean Front at 29th Street, MIAMI BEACH, FLORIDA

Arthur Pancoast built the fashionable Pancoast Hotel on the oceanfront at Twenty-ninth Street. The hotel, designed by John Collins's grandson Russell T. Pancoast, opened in January 1924. The "atmosphere of Old Spain" was enjoyed by guests of the expensive hotel. (Published by Lumitone.)

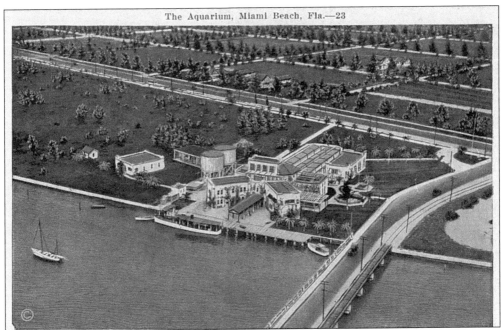

The Miami Beach Aquarium was built by Jim Allison just north of Fifth Street at a cost of $150,000. John Oliver LaGorce, publisher of *National Geographic Magazine*, brought Alexander Graham Bell and his sons-in-law David Fairchild and Gilbert Grosvenor to the board of directors. (Published by Charles Shaw.)

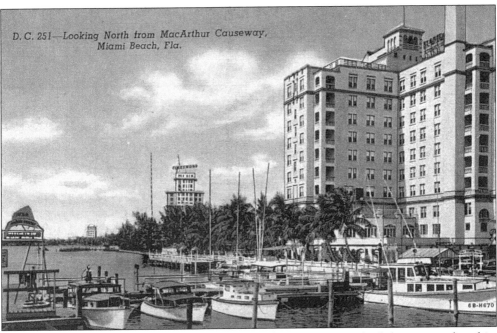

D. C. 251—Looking North from MacArthur Causeway, Miami Beach, Fla.

By the time this postcard was produced in 1946, the aquarium had disappeared and its site was occupied by high-rise buildings. The dock was being utilized for charter fishing trips. (Published by Curt Teich.)

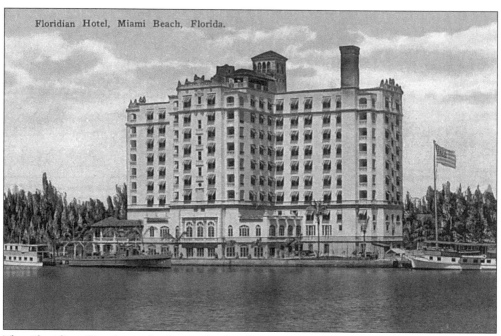

The Floridian Hotel was built on the bayfront at Sixth Street in 1925. The spacious hotel offered 252 rooms, each with its own bath. (Published by E.C. Kropp.)

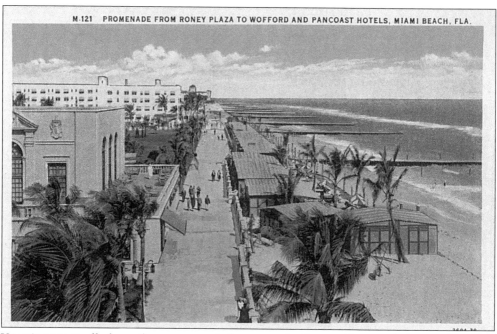

Vacationers stroll along the promenade between the Roney Plaza and the Wofford and Pancoast Hotels. The cabanas of the Roney Plaza can be seen along the beach. (Published by Curt Teich.)

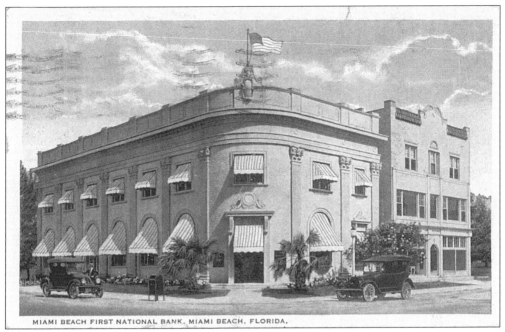

MIAMI BEACH FIRST NATIONAL BANK, MIAMI BEACH, FLORIDA.

Unlike today, parking was not a problem for customers arriving to conduct business at the Miami Beach First National Bank, as can be seen from this *c.* 1920 postcard. (Published by Curt Teich.)

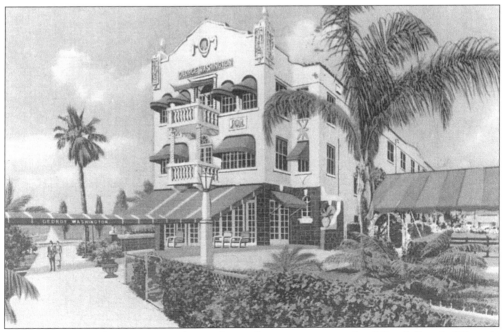

The George Washington Hotel stands at the entrance to the Miami Beach Historic District at 534 Washington Avenue. William P. Brown designed the Mediterranean Revival building in 1924. (Courtesy of Historical Museum of Southern Florida.)

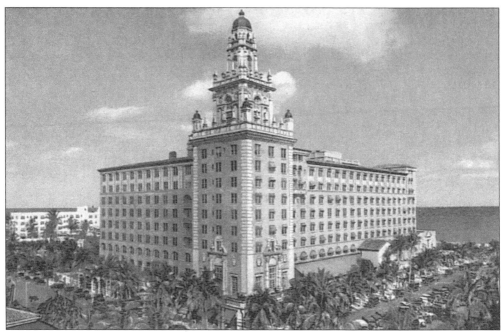

The site pictured above was once offered by Carl Fisher at no cost to any developer who would build a major hotel on it. No one was interested at the time. In 1925, just over a decade later, N.B.T. Roney paid $2.5 million for the site, on which he built his Roney Plaza Hotel. The hotel, which opened in 1926, included 15 acres of formal gardens, 1,500 feet of ocean frontage, cabanas, and restaurants. The original Roney Plaza was torn down in 1968 and the current Roney Plaza apartment/hotel building was built on the site. (Published by K.S. Tanner Jr.)

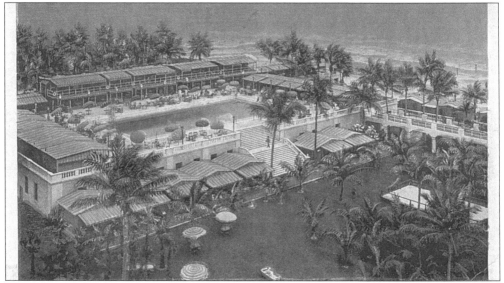

The Roney Plaza Cabana Sun Club offered bathing cabins for private sunbathing, a massage, or al fresco dining. These were all unique delights for people escaping the cold winter winds. (Published by E.C. Kropp.)

The Spanish Village at Espanola Way was built by N.B.T. Roney in 1925. Robert Taylor designed the picturesque Mediterranean Revival buildings, which were originally intended to be an artist's colony. Desi Arnaz created the rumba craze on Espanola Way when he played at the Village Tavern and wrote "The Miami Beach Rhumba." The old-world ambiance of the village made it a popular setting for scenes in the *Miami Vice* television series. Espanola Way was beautifully restored in 1986 by Polonia Restoration. (Published by E.C.Kropp.)

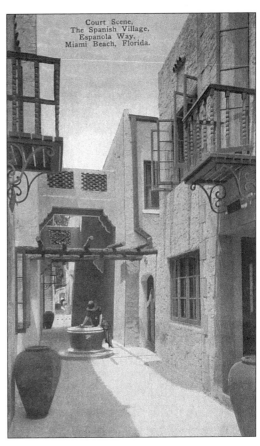

The current Clay Hotel and International Youth Hostel, located at the corner of Espanola Way and Washington Avenue, has a colorful past. Al Capone's S. and H. Gambling Syndicate took over the middle wing (now rooms 128–138) for a gambling casino. The totally renovated hotel is a vibrant and popular tourist destination. (Courtesy of Florida State Archives.)

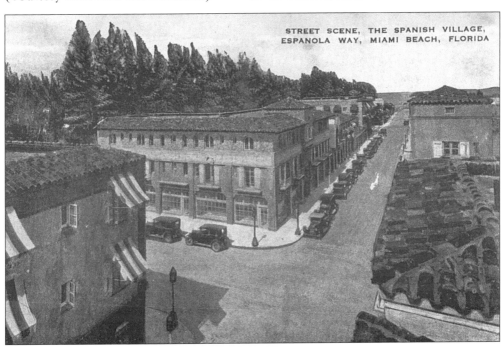

35

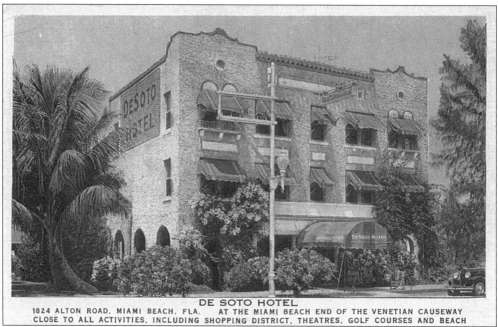

The pride with which the DeSoto Hotel was maintained by its owners is apparent in this *c.* 1930 postcard. The DeSoto was located at 1824 Alton Road. (Published by Tichnor Bros.)

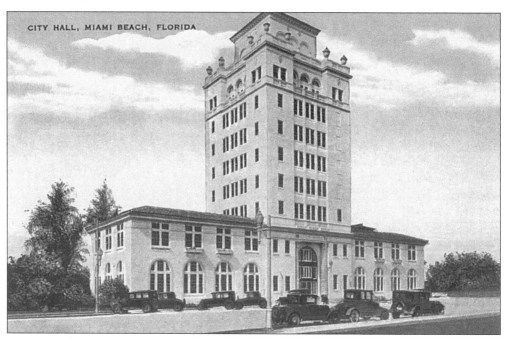

Martin Luther Hampton designed the Mediterranean/Beaux Arts–style Miami Beach City Hall, which opened on January 1, 1928. The building, located at 1130 Washington Avenue, was used until 1977, when a new administration center opened on Convention Center Drive. (Published by Pictorial Center.)

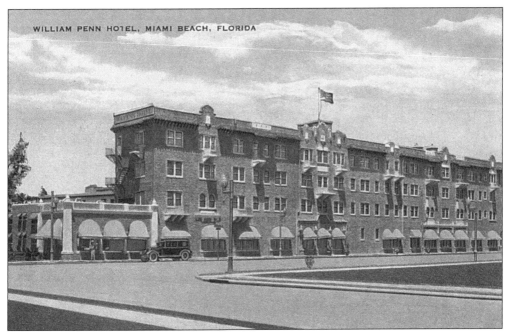

The poem on the back of this *c.* 1925 postcard of the William Penn Hotel describes the vacationland then and now: "I'm here where gay poinsettas bloom, Where grows the stately palm, Where sunshine drives away the gloom, And nature brings her balm. To those who come and linger here, And fills their hearts with joy and cheer." (Published by Pictorial Center.)

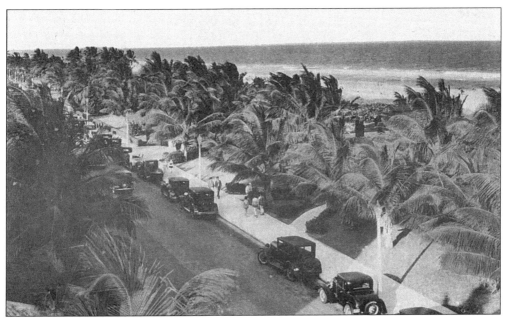

The lush landscaping and abundance of palm trees can be seen in this early 1920s view of Lummus Park and Ocean Drive. (Published by Sunny Scenes, Inc.)

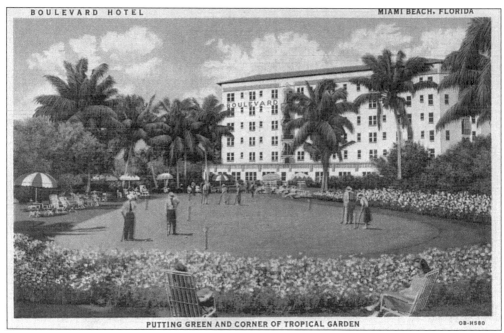

BOULEVARD HOTEL MIAMI BEACH, FLORIDA

PUTTING GREEN AND CORNER OF TROPICAL GARDEN OB-H580

Guests fine tune their skills on the putting green at the Boulevard Hotel. Carl Fisher built the 7-story, 226-room hotel in 1925. The hotel remained popular until it was demolished in 1980. (Published by Curt Teich.)

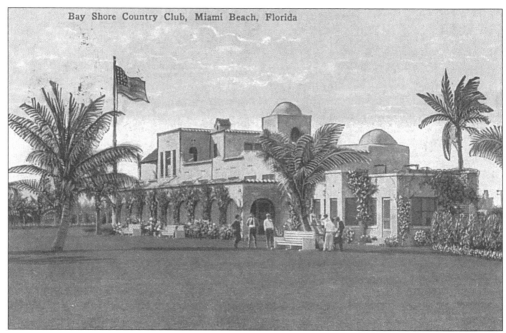

Bay Shore Country Club, Miami Beach, Florida

The Boulevard Hotel was conveniently located next to the new Bayshore Golf Club, shown above in this *c.* 1925 postcard. (Published by E.C. Kropp.)

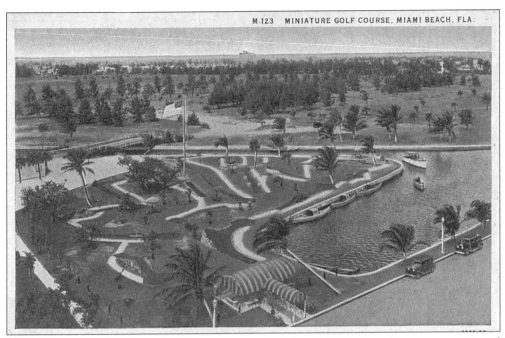

Not all golf was played on the large courses. This late 1920s view shows a recreational spot that offered a miniature golf course and boat rentals. (Published by Curt Teich.)

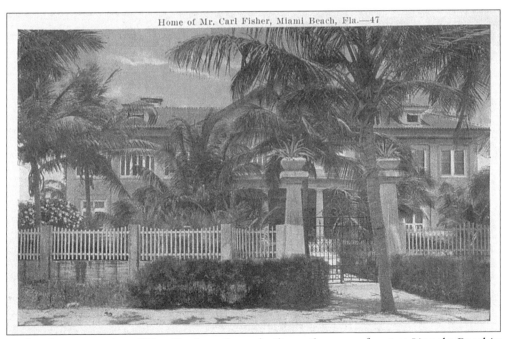

Home of Mr. Carl Fisher, Miami Beach, Fla.—47

Carl Fisher's mansion, "The Shadows," was built on the oceanfront at Lincoln Road in 1915. The home's cost of $65,000 was considered a fortune at the time. N.B.T. Roney, the developer of the Roney Plaza, bought the home in 1925. Today the Decoplage stands on the land where the Shadows once stood. (Published by S.H. Kress Co.)

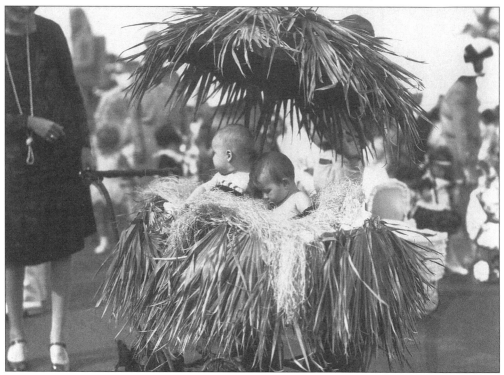

A young woman smiles at two babies that are taking part in the *c.* 1920s "Baby Parade" in their very tropical carriage. (Courtesy of the Romer Collection, Miami-Dade Public Library.)

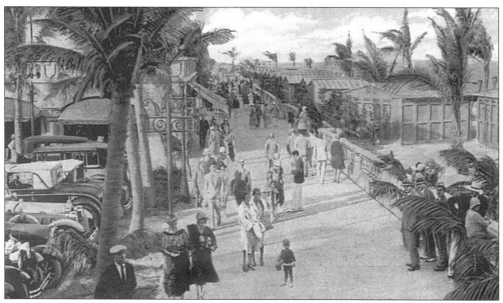

N.B.T. Roney knew what he was doing when he chose this site for his Roney Plaza Hotel. The Promenade between the beach and the hotel bustled with activity during the winter season. (Published by Curt Teich.)

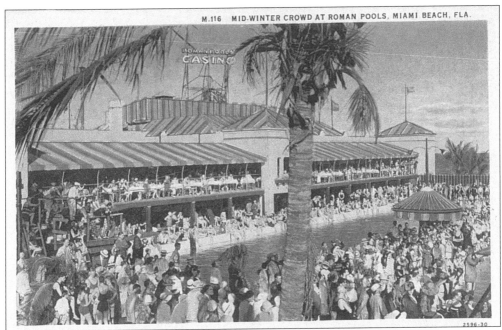

The Roman Pools attracted enormous crowds of people with special events such as the swimming and diving exhibitions. (Published by Curt Teich.)

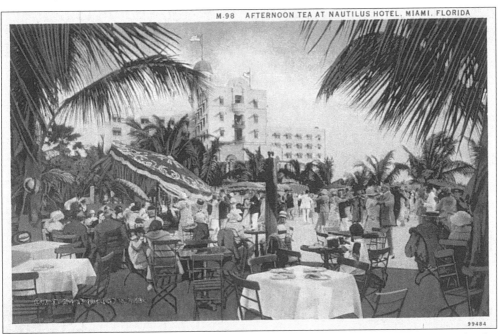

Shown here, a large crowd enjoys the afternoon tea dance at the Nautilus Hotel. The good life was in full swing at the various resorts in the city. Real estate values had soared more than 1,000 percent between 1914 and 1926. By the middle of 1926, however, the inflationary spiral and the building boom were slowing down. On September 18th, nature would make things much worse. (Published by Curt Teich.)

Five Cents
No More

MIAMI DAILY NEWS

VOLUME XXXI. NO. 104. MIAMI, FLA., SATURDAY, SEPTEMBER 18, 1926

HURRICANE HITS MIAMI

Tidal Wave Sweeps Bayshore Drive, Wrecking Boats
Fear Felt For Miami Beach, Pounded by Heavy Sea:

Miami was laid waste Saturday by a raging hurricane, attended by a gale of more than 130 miles an hour velocity, and followed by one of the most disastrous tidal waves ever experienced on the Atlantic Coast.

Miami Beach was isolated from the mainland and no word has been received as to the effect of the storm there. It is feared that a monster tidal wave has swept across the entire island city.

Newspapermen crawled from Miami Beach at 3 a. m. with a story of pounding surf, broken communication and distressed boats. It was the last information to reach Miami.

Scores of houses in Hialeah were reported leveled by the hurricane and under water from the overflow of the canal.

Coral Gables was cut off from all outside communication at 4:40 a. m. Saturday. Continued efforts to reach the city by wire were impossible during early hours of the morning.

All boats on Miami waterfront except one, Adventurer II, were sunk. The Nohab, former yacht of ex-Kaiser Wilhelm, was split in two.

The hurricane reached Miami between 2 and 3 a. m., following by only a few hours a precautionary hurricane warning issued by the Washington weather bureau.

A hurried check of damage in Miami, made during a momentary lull in the storm and a change of wind direction about 7 a. m., showed losses in the city proper are beyond comprehensive estimate.

The official weather bureau barometer at 5:50 a. m. registered 27.75 inches—the lowest ever recorded in the history of the U. S. weather bureau, according to Richard W. Gray, government meteorologist here. Normal standing of the barometer is 29.80. Galveston, Texas, during the disastrous hurricane and tidal wave in 1900, registered a barometric pressure of 28.40.

Miami river was out of banks, flooding Allapattah and the northwest section of the city.

Merrill & Stevens' shipyard was a mass of wreckage. Pleasure yachts under the sheds suffered heavy damage. Telephone and electric light poles were hurled into the Miami river.

Without power to set type or operate a press, The Daily News is publishing this miniature edition of a newspaper as a duty to its readers. It will continue to issue bulletins as often as possible.

BAROMETER READINGS

The barometer began dropping from its normal point Friday afternoon. At 10 p. m. it registered 29.64. Subsequent readings were:

12 a.m. 29.54	2.45 a.m. 29.24	3.45 a.m. 28.95	4.40 a.m. 28.57
1 a.m. 29.44	3 a.m. 29.19	3.30 a.m. 28.96	4.45 a.m. 28.50
1.30 a.m. 29.40	3.30 a.m. 29.15	3 a.m. 28.88	4.55 a.m. 28.45
2 a.m. 29.35	3.15 a.m. 29.12	4.00 a.m. 28.86	5.25 a.m. 28.49
2.30 a.m. 29.25	3.35 a.m. 29.00	4.20 a.m. 28.72	5.15 a.m. 28.40

MEET THE CRISIS

EDITORIAL

Miami has been the victim of a great catastrophe. Few, if any, have escaped the effects of the hurricane.

But this is a time when personal loss must give way to the common good; when Miami must meet the situation as it should be met.

This is a time for a high degree of courage, but Miami has it. This is a time for unity of action

The booming economy and happy life were struck a devastating blow with the arrival of the great hurricane of 1926. The front page of the *Miami Daily News*, shown above, describes the destruction dealt by the storm. Communication was cut off between Miami Beach and the mainland and everyone feared the worst. (Courtesy of Florida State Archives.)

Two

TRIUMPH OVER ADVERSITY

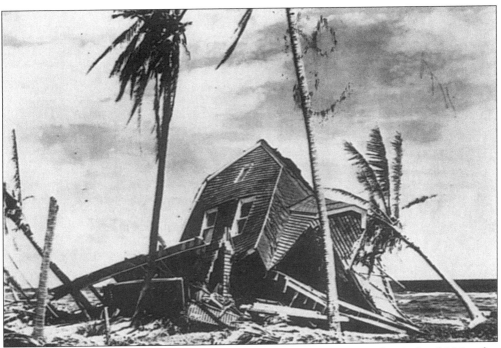

Around 2 a.m. on the morning of September 18th, a hurricane with winds of 125 miles per hour struck the Miami area. Unaware that the temporary calm was the eye of the storm passing over, residents came out to view the damage, only to be hit with the second half of the storm. Hundreds of people were killed, homes and businesses were destroyed, and the building boom ended. This house, located on the oceanfront near Twenty-eighth Street, was no match for the destructive power of the hurricane. (Courtesy of Florida State Archives.)

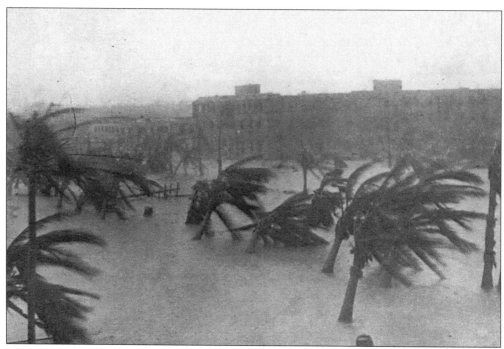

The awesome effect of the storm surge is evident in this scene of Miami Beach, where the ocean came in and met the bay. Shown in this photo, waist-deep water and high winds pummel the city. (Courtesy of Florida State Archives.)

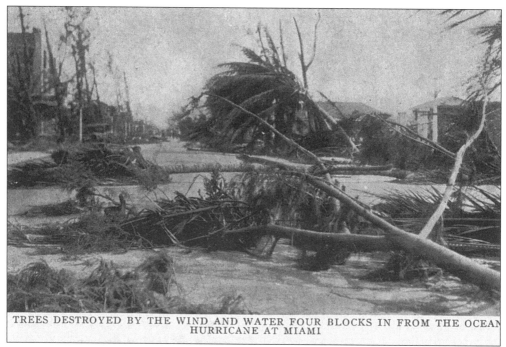

TREES DESTROYED BY THE WIND AND WATER FOUR BLOCKS IN FROM THE OCEAN
HURRICANE AT MIAMI

High winds uprooted trees and caused extensive damage on this street located four blocks from the ocean. (Courtesy of Florida State Archives.)

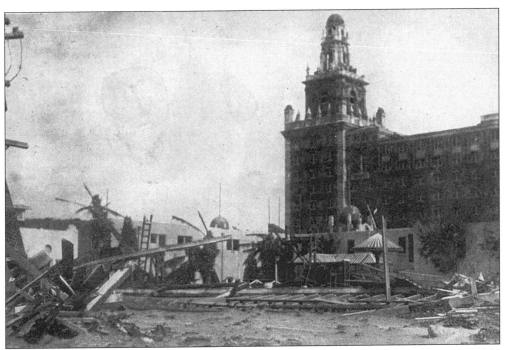

The shattered remains of the famous Roman Pools mark the end of the many enjoyable times the facility brought its visitors. The Roney Plaza Hotel stands in the background. (Courtesy of Florida State Archives.)

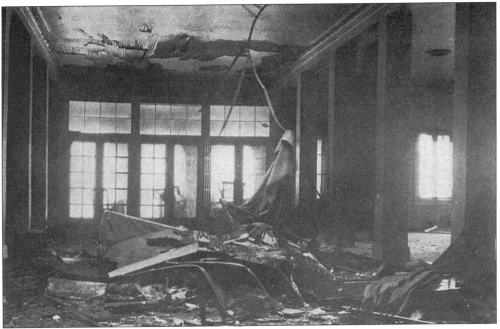

This photograph shows the extensive damage to the lobby of the Wofford Hotel, previously shown on page 31. The postcard states that two persons were reported killed at this site. (Courtesy of Florida State Archives.)

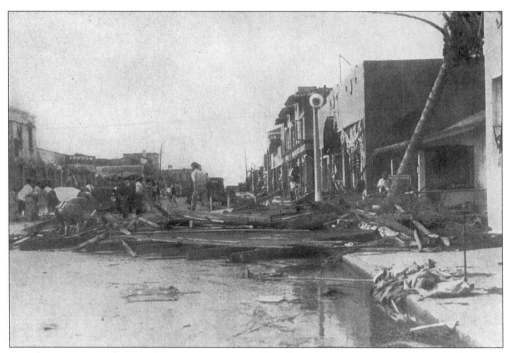

Residents survey the Washington Avenue and Fifth Street area after it suffered severe damage from a tornado. (Courtesy of Florida State Archives.)

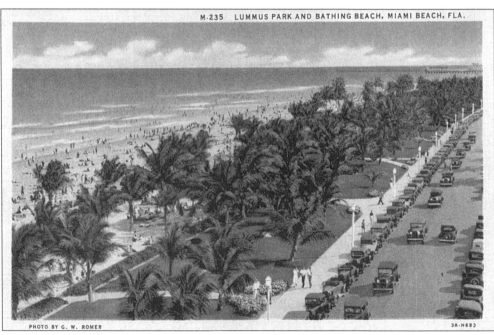

The tourism industry was set back by the 1926 hurricane, the stock market crash in 1929, and the early Depression years; however, things were picking up again by the time of this 1933 postcard. The beach is filled with vacationers, and like today, there's not a parking space open on Ocean Drive. (Published by Curt Teich.)

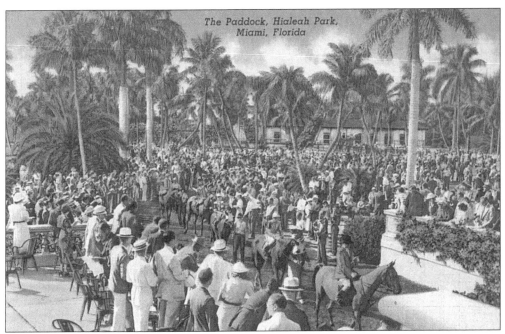

Parimutuel betting on horse races helped sustain the flow of tourists during the 1930s and was of enormous benefit to the local economy. Shown above, well-dressed crowds watch the jockeys and horses at the Paddock at Hialeah Park in Miami. (Published by Curt Teich.)

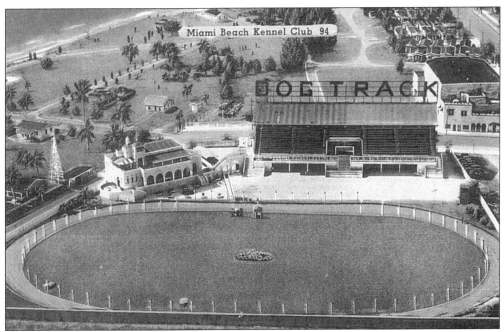

The Florida legislature also made parimutuel betting on dog races legal. The well-attended races were held at the Kennel Club in Miami Beach. (Published by Tichnor Bros.)

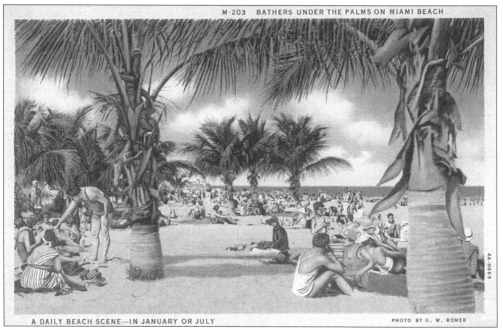

A DAILY BEACH SCENE—IN JANUARY OR JULY

PHOTO BY G. W. ROMER

This 1934 postcard gives a close-up look at the beach fashions of the day. The vacationers are relaxing amidst the palms at Lummus Park. (Published by Curt Teich.)

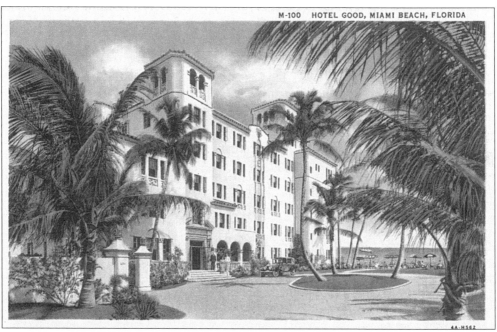

M-100 HOTEL GOOD, MIAMI BEACH, FLORIDA

This postcard, produced in 1934, shows the Hotel Good, which was an example of the many Mediterranean Revival hotels built in the resort city. (Published by Curt Teich.)

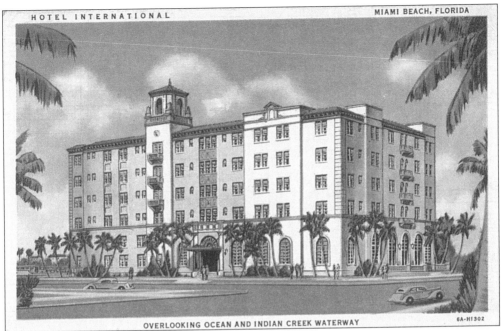

OVERLOOKING OCEAN AND INDIAN CREEK WATERWAY 6A-H1302

The Hotel International, shown in this 1936 postcard, was located at Collins Avenue and Forty-third Street on the Indian Creek Waterway. Although it was not located on the oceanfront, hotel guests received membership privileges at the Beach Cabana Club across from the hotel. (Published by Curt Teich.)

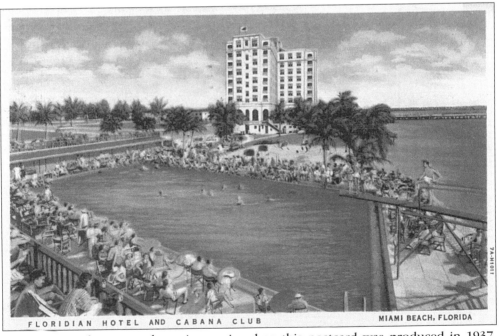

FLORIDIAN HOTEL AND CABANA CLUB MIAMI BEACH, FLORIDA

The tourist industry was booming again when this postcard was produced in 1937. There appears to be standing room only around the swimming pool at the Floridian Hotel and Cabana club. (Published by Curt Teich.)

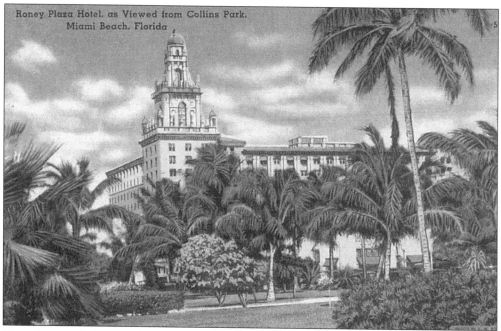

On February 6, 1913, John Collins donated the land between Twenty-first and Twenty-third Streets to the city for use exclusively as a public park. This *c.* 1940 view shows Collins Park and the Roney Plaza Hotel. The hotel's tower was inspired by the Giralda Tower in Seville, Spain. The Giralda Tower was also the model for the tower of the Biltmore Hotel in Coral Gables and the Miami News Tower (known today as the Freedom Tower) on Biscayne Boulevard. (Published by Tichnor Bros.)

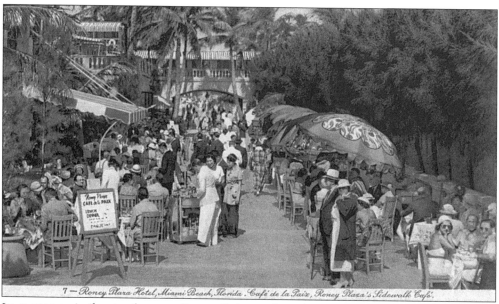

7 — Roney Plaza Hotel, Miami Beach, Florida. Café de la Paix, Roney Plaza's Sidewalk Café.

In a scene similar to that on Ocean Drive today, the sidewalk cafes are filled with visitors on a beautiful South Florida day. Crowds enjoy the food and atmosphere at the Café de la Paix, Roney Plaza's sidewalk café. (Published by K.S. Tanner Jr.)

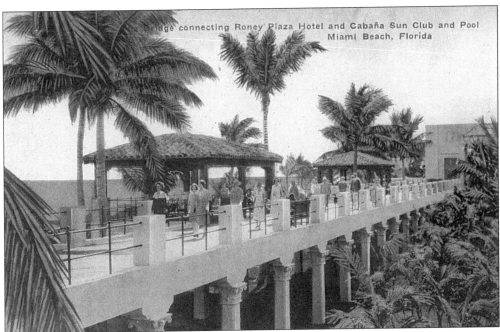

Vacationers stroll across the bridge connecting Roney Plaza Hotel and the Cabana Sun Club. (Published by the Albertype Co.)

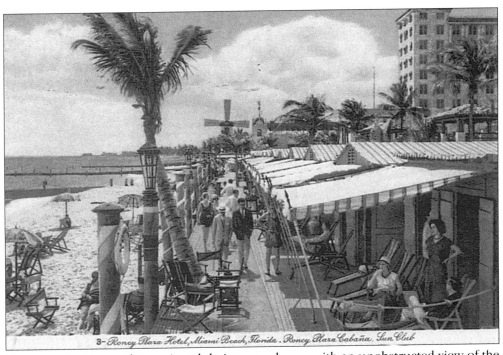

Guests at the Roney Plaza enjoyed their own cabanas with an unobstructed view of the tropical waters. (Published by K.S. Tanner Jr.)

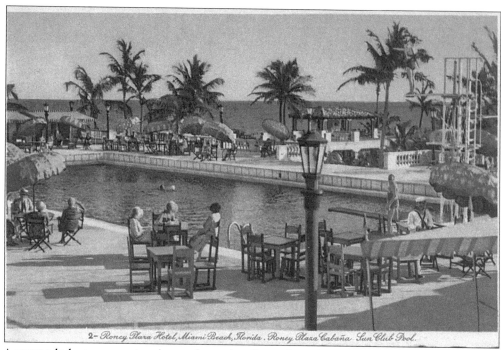

A young lady prepares to plunge from the diving board at the Roney Plaza pool, while other guests bask in the midday sun. (Published by K.S. Tanner Jr.)

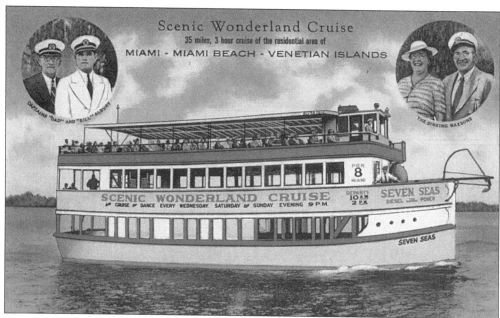

Captains "Dad" and "Bill" Albury guide their passengers on a three-hour sightseeing cruise along Biscayne Bay aboard the *Seven Seas* yacht, shown in this 1941 postcard. (Published by Curt Teich.)

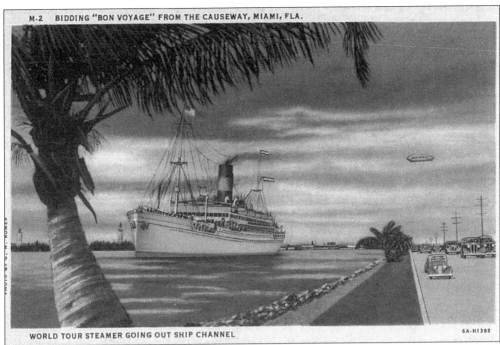

WORLD TOUR STEAMER GOING OUT SHIP CHANNEL 6A-H1398

As it does today, the Causeway (renamed the MacArthur Causeway in 1942) offered an excellent view of cruise ships as seen in this 1936 postcard. Passengers can be seen lined up along the deck waving to the people along the shore. In the distance, the Goodyear blimp is returning to its base on Watson Island. (Published by Curt Teich.)

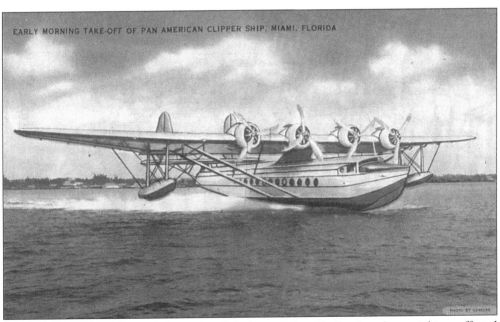

EARLY MORNING TAKE-OFF OF PAN AMERICAN CLIPPER SHIP, MIAMI, FLORIDA

The Causeway also provided a splendid view of the Chalks Seaplanes taking off and landing just off Watson Island. (Published by Curt Teich.)

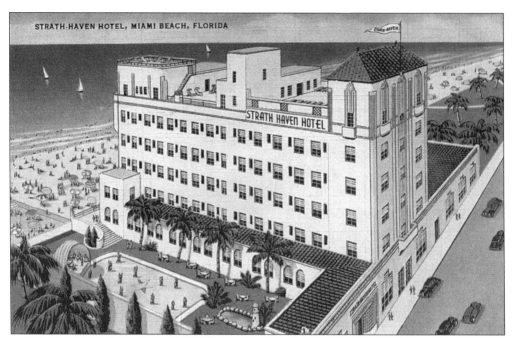

STRATH-HAVEN HOTEL, MIAMI BEACH, FLORIDA

The Strath Haven Hotel was located on the oceanfront between Fourth and Fifth Streets. The hotel offered its guests a private beach, two dining rooms, a cocktail lounge, and a lovely Marine Garden, shown below. (Published by Curt Teich.)

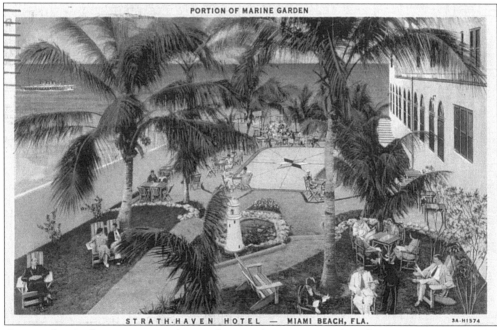

Guest relax in the Marine Garden at the Strath Haven Hotel in this 1933 postcard. The garden was decorated with a miniature lighthouse and other nautical items. (Published by Curt Teich.)

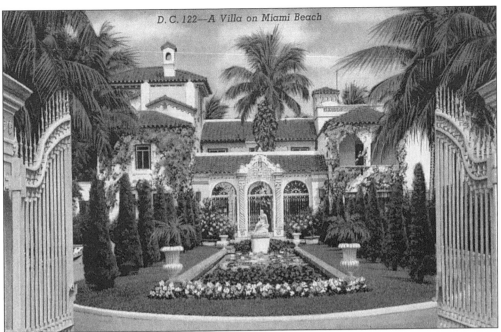

D.C. 122—A Villa on Miami Beach

The Leon Sigman Estate exemplified the magical beauty of the lavish Mediterranean Revival mansions in Miami Beach that rivaled Palm Beach grandeur. The arched colonnades, romantic balconies, bell towers, and sweeping gardens created an aura of magic and fantasy. (Published by Curt Teich.)

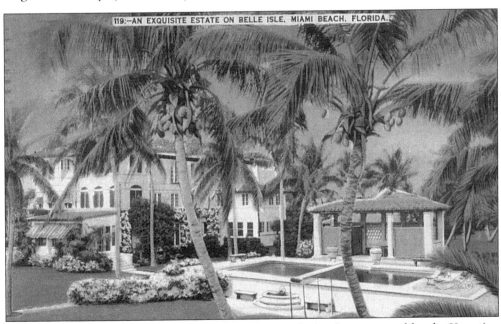

119:—AN EXQUISITE ESTATE ON BELLE ISLE, MIAMI BEACH, FLORIDA.

Bell Island is the only natural island in the chain of islands connected by the Venetian Causeway. At the time of the opening of the Collins Bridge in 1913, the island was known as Bull Island. Shown here is one of the many exquisite and palatial homes on the island. (Published by the Dade County Newsdealers Supply Co.)

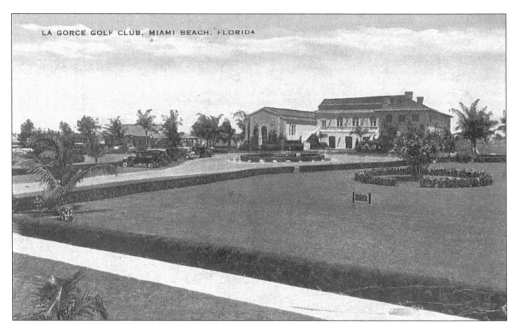

The La Gorce Country Club opened in 1927 and is enjoyed by its members to this day. (Published by Pictorial Center.)

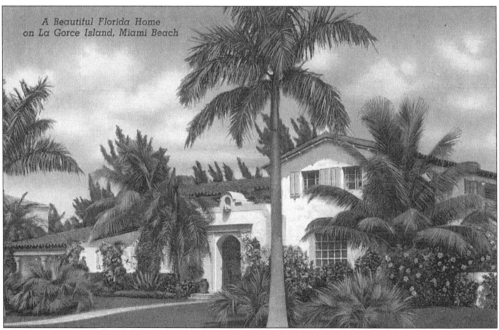

When Carl Fisher created this island, he named it after his lifelong friend John Oliver LaGorce, the publisher of *National Geographic Magazine*. This late 1930s view shows one of the many beautiful homes on La Gorce Island. (Published by Curt Teich.)

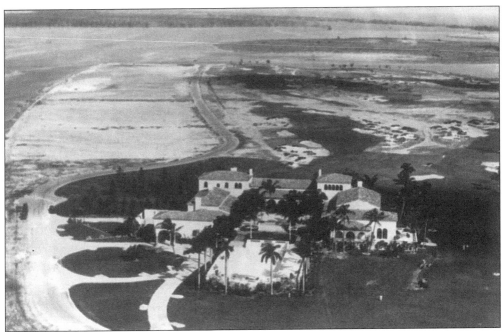

This late 1920s aerial view shows the Indian Creek Country Club on Indian Creek Island, which was later incorporated in the 1930s. Today, members still enjoy the beautifully maintained club, the special events, tennis, golf, and croquet. (Courtesy of Historical Museum of South Florida.)

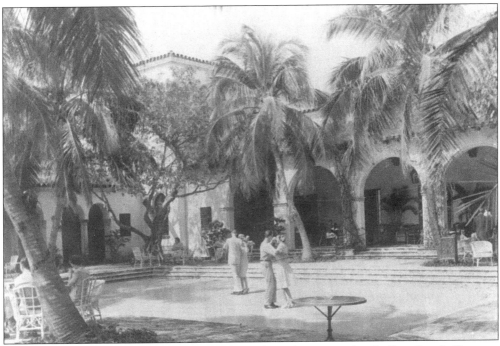

Couples enjoy a dance in the courtyard before dinner at the Indian Creek Country Club. (Courtesy of Historical Museum of South Florida.)

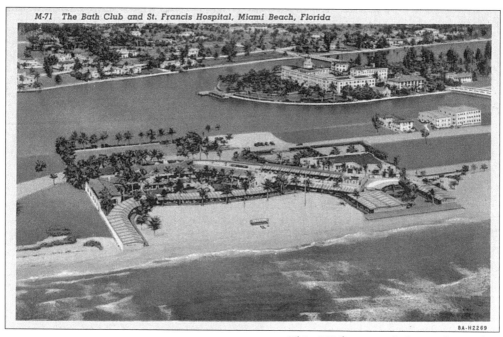

BA-H2269

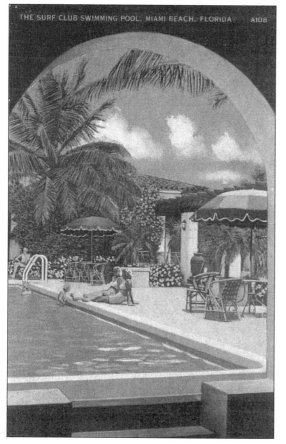

THE SURF CLUB SWIMMING POOL, MIAMI BEACH, FLORIDA A108

This 1936 postcard shows the Bath Club, which was built at 5937 Collins Avenue in 1928. At the time of its opening, the location was considered quite "far north" on the beach. Memberships were offered at $1,500 and were quickly sold out. The rambling building on the island on the Indian Creek waterway is the St. Francis Hospital. (Published by Curt Teich.)

When the memberships at the Bath Club were sold out, the remaining applicants went further north to Ninety-second Street and opened the beautiful Surf Club in what is now Surfside. This late 1930s postcard shows members enjoying a relaxing chat at the swimming pool. (Published by Colourpicture.)

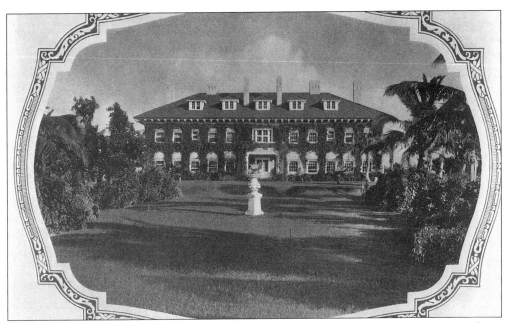

Harvey Firestone bought the lavish estate with the Beaux Arts–style mansion from James Snowden, the motor oil magnate. In 1954, Ken Novak purchased the property to be the site of the new Fontainebleau Hotel, and the mansion was demolished. (Courtesy of Florida State Archives.)

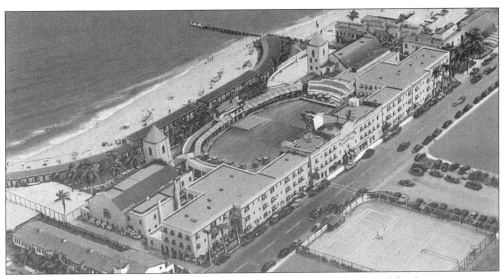

The Deauville Hotel was built in 1924 by Joe Elsener. The hotel had an enormous dining room and a 100-foot-wide-by-165-foot-long swimming pool. However, the Sixty-third Street location was considered too far north, and the hotel closed during the Depression. In 1934, Lucy Magraw bought the hotel and turned it into a high-class gambling resort. Mrs. Magraw later leased it to physical fitness enthusiast Bernarr MacFadden, who operated the MacFadden-Deauville as a health resort. In the 1950s, the Deauville shown here was demolished and replaced with a new Deauville Hotel. (Published by Tichnor Bros.)

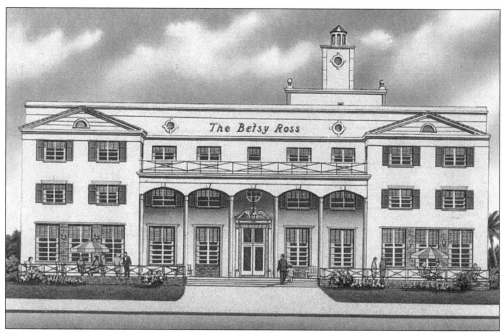

The Betsy Ross Hotel was designed in the Neo-classical Revival style by L. Murray Dixon in 1941. The lovely restored hotel still stands at 1440 Ocean Drive. (Published by Colourpicture.)

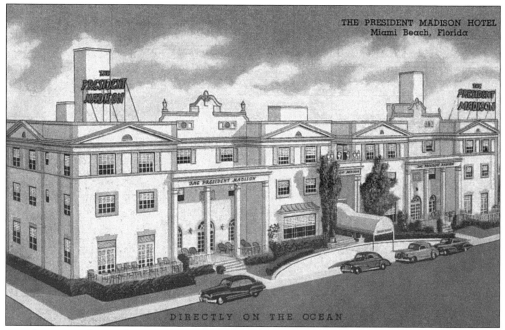

Another Neo-classical Revival hotel, the President Madison, occupies the entire block from Thirty-eighth Street to Thirty-ninth Street on Collins Avenue. At the time of this postcard's production in 1947, the hotel's rates were $2 per person per day, and two guests to a room. (Published by Curt Teich.)

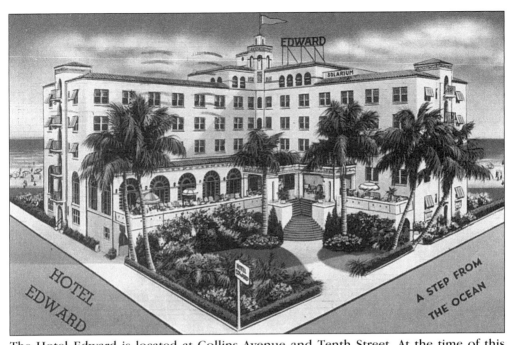

The Hotel Edward is located at Collins Avenue and Tenth Street. At the time of this *c.* 1940 card, rates started at $10 weekly for a single and $12 weekly for a double. (Published by Colourpicture.)

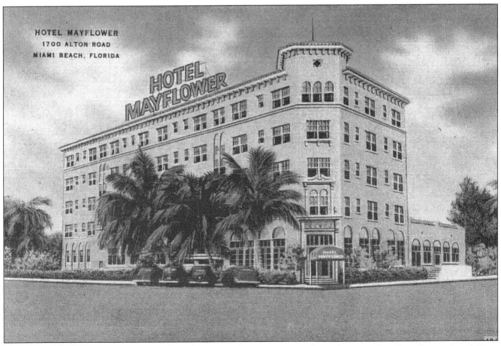

Mediterranean Revival was Florida's predominant style prior to the Art Deco building boom. Another popular hotel of that genre was the Hotel Mayflower, located at 1700 Alton Road. (Published by Colourpicture.)

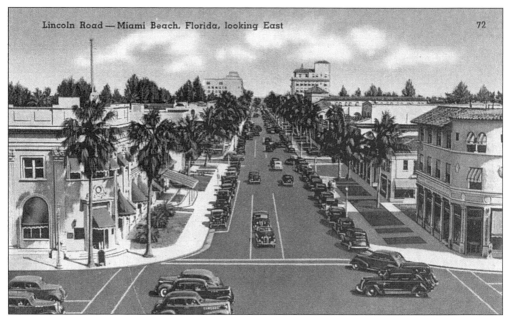

Lincoln Road had evolved from a mangrove swamp in 1914 to a busy thoroughfare by the time of this mid-1930s postcard. Lincoln Road was considered Miami Beach's finest shopping area during the 1930s and 1940s. With stores such as Saks Fifth Avenue, Bonwit Teller, and Harry Winston Jewelers, it was considered the "Fifth Avenue of the South." Today the Miami City Ballet rehearses at the former site of the Bonwit Teller store at 905 Lincoln Road. (Published by Tichnor Bros.)

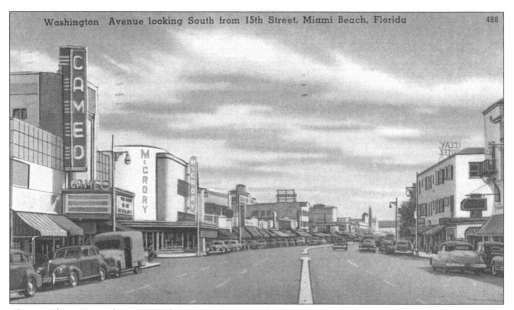

This 1940s view shows Washington Avenue looking south from Fifteenth Street. The Cameo Theater, shown on the left, was built in 1938 by Robert Collins. An unusual carved cameo façade remains at the entrance to the 980-seat theater, which is still in use today. (Published by Tichnor Bros.)

Three

REDISCOVERED TREASURES

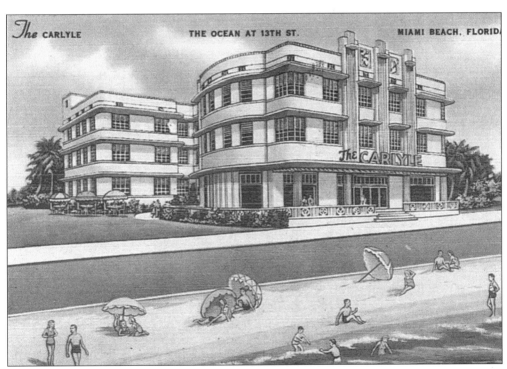

The 1930s and 1940s brought the creation of the Art Deco gems that today make up the Miami Beach Art Deco Historic District. Architects used motifs of the Art Deco style first seen in Europe in the 1920s and the streamlined shapes made popular by industrial designers of the 1930s. Shown here, the Carlyle Hotel was designed by architects Kiehnel and Elliott in 1941. One of the finest examples of the streamline style, it was used in the film *The Birdcage* in 1995. The neon Carlyle sign was replaced by a "Birdcage" sign while the film was being made. (Published by Colourpicture.)

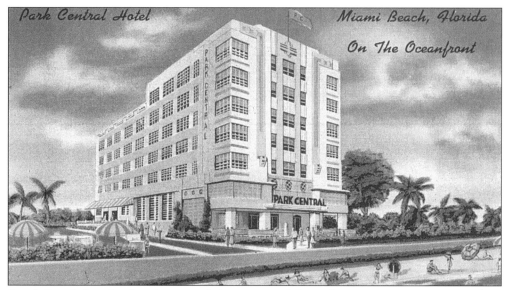

South Beach hotels often borrowed the names of their "big city" counterparts, such as the Park Central Hotel, shown in this *c.* 1940 postcard. Leading Art Deco architect Henry Hohauser designed the seven-story hotel in 1937. The Park Central, located at 640 Ocean Drive, evokes a real sense of the 1930s with its porthole windows and center vertical stripes. The hotel, restored by Tony Goldman, shows off original terrazzo floors and wrought-iron stairwells throughout the lobby. (Published by Colourpicture.)

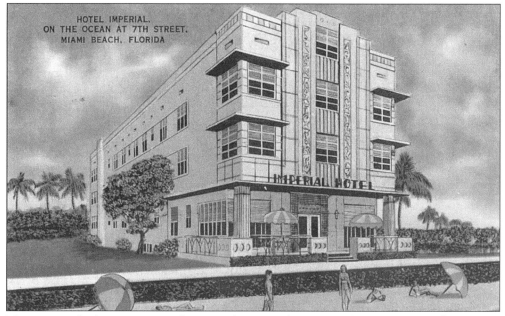

The Imperial, shown in its infancy in this *c.* 1940 postcard, is located at 650 Ocean Drive. L. Murray Dixon designed the hotel in 1939. The Imperial's design reflects the neighboring Park Central Hotel, an example of how the architects worked together in creating a cohesive community of Art Deco treasures. L. Murray Dixon used vertical lines in the center, embellished with floral plaques. (Published by Colourpicture.)

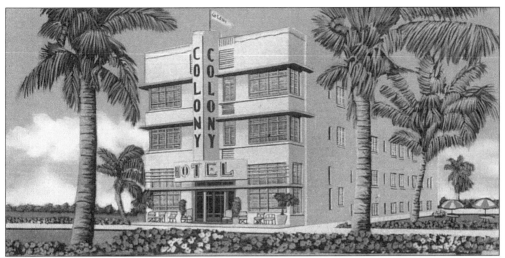

One of Henry Hohauser's masterpieces, the Colony Hotel, was designed in 1935. Located at 736 Ocean Drive, the Colony has one of the most famous neon signs in the historic district. The racing stripes and long eyebrows over the windows create horizontal interest that provide contrast to the powerful center sign. The hotel lobby, with its fireplace faced with green vitrolite and a "Diego Rivera-like" mural, is a favorite among Art Deco enthusiasts. (Published by Colourpicture.)

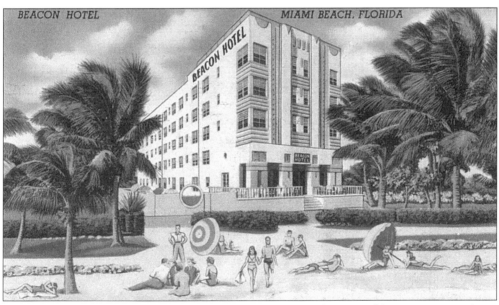

The Beacon Hotel, located at 720 Ocean Drive, was built in 1936 by Henry O. Nelson. This Art Deco classic has beautifully ornamented, vertical center lines and horizontal racing stripes—elements commonly used in the classic Art Deco style. The Beacon Hotel re-opened in the fall of 1999 after a multi-million-dollar renovation that added elegance and comfort to the already popular hotel in addition to a new sidewalk café. The use of tropical images and etched glass added a special touch to Art Deco buildings. The image of a flamingo etched in glass can be found in the Beacon's fine lobby. (Published by Colourpicture.)

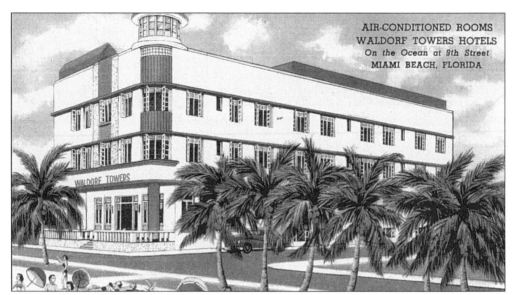

Chicago architect Albert Anis designed the Waldorf Towers Hotel in 1937. The hotel, located at 860 Ocean Drive, is shown above in a c. 1940 postcard. The two long rows of "eyebrows" over the windows flow continuously along the rounded corner, providing sleek horizontal lines. The ornamental lighthouse tower on the Waldorf Towers Hotel is an example of the seashore's influence on the architecture of South Beach. The splendid tower was considered unsafe by the city and torn down in the 1980s. Developer Gerry Sanchez deserves an ovation for rebuilding the tower during his restoration of the Ocean Drive classic in 1985. (Published by Curt Teich.)

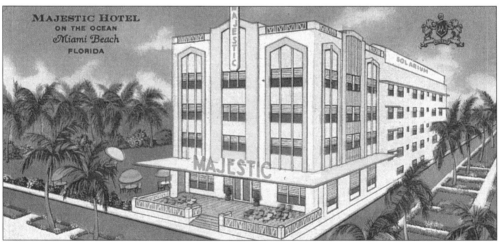

A few years later, in 1940, Albert Anis also designed the Majestic Hotel. The hotel, shown above in a c. 1942 postcard, is located at 660 Ocean Drive. As can be seen, postcards produced in the 1930s and 1940s showed each hotel individually, usually surrounded by landscaped lawns and practically at the ocean's edge. Telephone poles, electric wires, neighboring buildings, traffic (other than a few sleek "deco" cars), and pedestrians were airbrushed out. The resulting image was one that showcased each hotel in its full glory. The Majestic Hotel adds to the magic of Ocean Drive and is still a favorite gathering spot today. (Published by Curt Teich.)

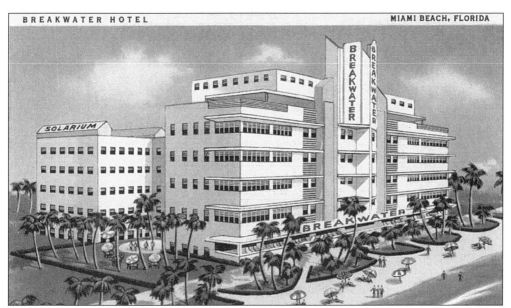

The Breakwater Hotel, at 940 Ocean Drive, was designed and built by Anton Skislewicz in 1939, the same year this postcard was produced. The double-faced neon sign is one of the most photographed and recognized images on South Beach. The classic streamline Moderne hotel has a striking central tower with a vertical double nameplate that echoes Mayan influence. Skislewicz achieved the strong horizontal emphasis by using the racing stripes and the solid lines of eyebrows above the windows. The rooftop railing is an example of nautical influence, suggesting the metal railings of an oceanliner. (Published by Curt Teich.)

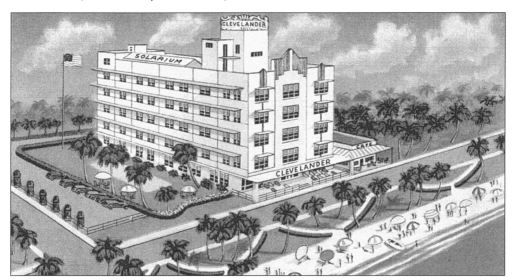

Albert Anis designed the Clevelander Hotel at 1020 Ocean Drive in 1937. In this 1939 postcard, numerous umbrellas provide shade on the beach. One of the features that is frequently used in Art Deco buildings is the "parapet," which is a wall that extends above the roofline. An exquisitely designed parapet can be seen at the top of the Clevelander. (Published by Curt Teich.)

67

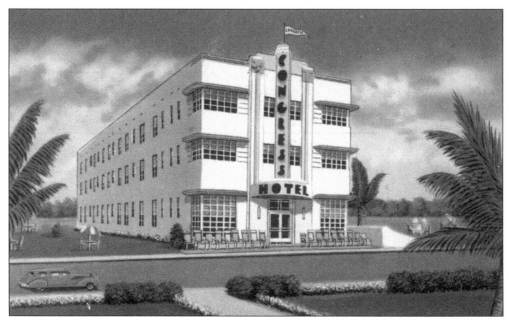

Henry Hohauser designed the Congress Hotel, located at 1036 Ocean Drive. This classic Art Deco design has three stories and a flat roof with wave-like fluting along the roofline, which is interrupted by a center parapet and a vertical name sign. (Published by Curt Teich.)

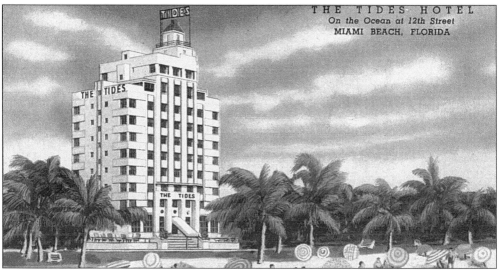

The Tides Hotel, located at 1220 Ocean Drive, was designed by architect L. Murray Dixon in 1936. At 12 stories, it was the tallest building on Ocean Drive. Native Florida "Oolitic limestone," commonly known as "keystone," was a favorite material of the Art Deco designers. It could be used in its natural color or tinted to coordinate with the overall decorative scheme. It can be seen on the facade of the Tides Hotel in its natural form as well as tinted. In 1997 the Tides Hotel was elegantly restored, at which time the original 112 rooms were converted into 45 units—a combination of rooms, suites, and penthouses. (Published by Curt Teich.)

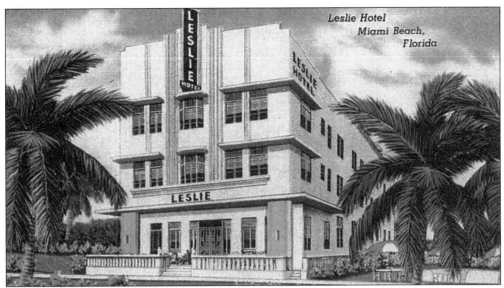

Leading Art Deco architect Albert Anis also designed the Leslie Hotel in 1937. The hotel, located at 1244 Ocean Drive, is an example of fine Art Deco design. In a classic Deco division, sometimes called the "holy three," buildings or parts of buildings were conspicuously divided into three parts with the two sides differing from the center part, forming an A-B-A pattern. The clever use of color emphasizes the middle "B" section, as does the "stepped" parapet along the roofline. (Publisher unknown.)

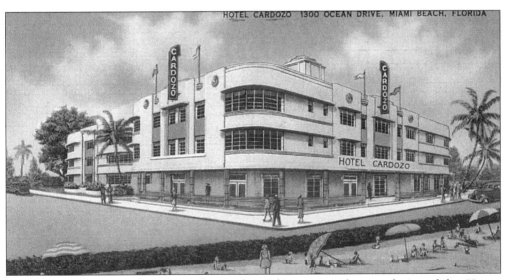

The Cardozo Hotel, shown in this early 1940s postcard, was designed by Henry Hohauser in 1939. The hotel was named after 1930s Supreme Court Justice Benjamin Cardozo. Featured in the 1959 film *A Hole in the Head*, starring Frank Sinatra, the hotel has also appeared in the background of many recent films. The Cardozo, located at 1300 Ocean Drive, was the first Art Deco hotel to be renovated during South Beach's revival in the 1980s. The classic streamline hotel is now owned by singer/entertainer Gloria Estefan. (Published by Colourpicture.)

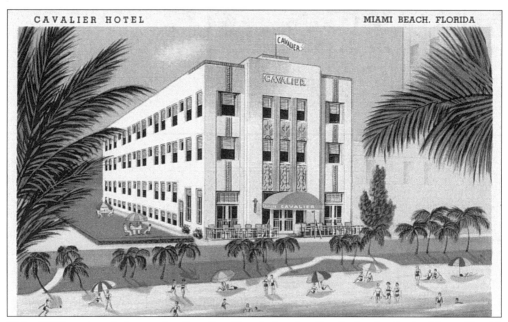

CAVALIER HOTEL MIAMI BEACH. FLORIDA

This 1937 postcard shows the Cavalier Hotel shortly after being built. Architect Roy F. France designed the classic Art Deco gem, which is located at 1320 Ocean Drive, in 1936. Today, the fully restored Cavalier is part of a collection of Art Deco hotels owned and operated by Island Outpost, which was founded by music mogul Chris Blackwell. (Published by Curt Teich.)

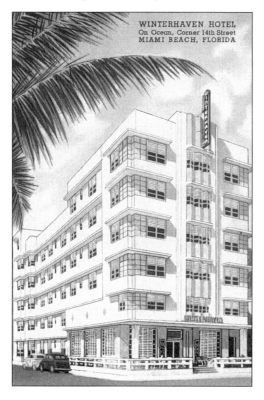

The Winterhaven, located at 1400 Ocean Drive, was designed by Albert Anis in 1939. The hotel, with its large multi-level lobby and 70 guest rooms, was completely restored in the spring of 2000. During the restoration, exact replicas were made of the original chandeliers, sconces, and the registration desk. (Published by Curt Teich.)

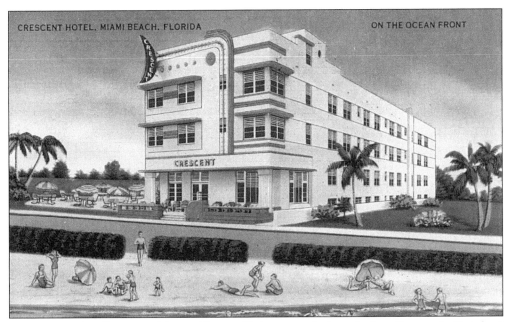

Prominent Art Deco architect Henry Hohauser designed the Crescent Hotel at 1420 Ocean Drive. The nautical influence can clearly be seen on the hotel, which sports decorative portholes and a rooftop metal railing. Although originally designed in 1938 as a 43-room hotel, the Crescent has been converted into 22 apartments. (Published by Colourpicture.)

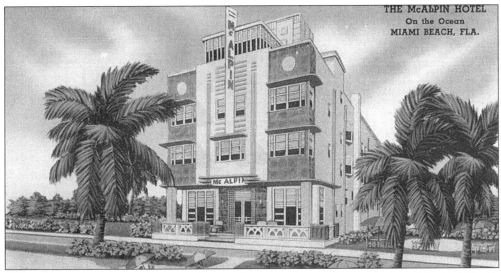

THE McALPIN HOTEL
On the Ocean
MIAMI BEACH, FLA.

This early 1940s postcard shows the McAlpin Hotel, which was designed in 1940 by L. Murray Dixon. Mr. Dixon, in another example of numerous architects creating cohesiveness in the community, linked the McAlpin (in spirit) to the Crescent next door in a variety of ways. By matching the height and the use of corner windows covered by eyebrows, he created a continuous horizontal line that flowed between the two buildings. Even the rooftop railings and portholes appear to flow from one building to the other. (Published by Colourpicture.)

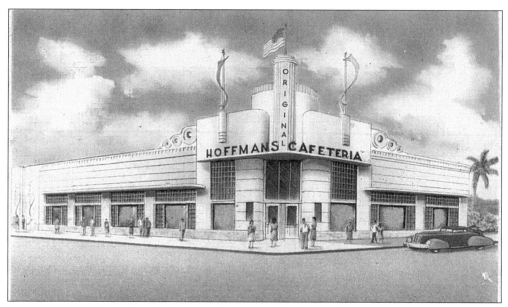

Wave-like designs and vertical images suggesting smokestacks or a ship's funnel could be seen in some of the Art Deco buildings. With a bit of imagination, the Hoffman Cafeteria building could be seen as an oceanliner, cutting through the ocean waters and creating foaming surf on each side. Henry Hohauser built the delightful building at 1450 Collins Avenue in 1939. (Published by Colourpicture.)

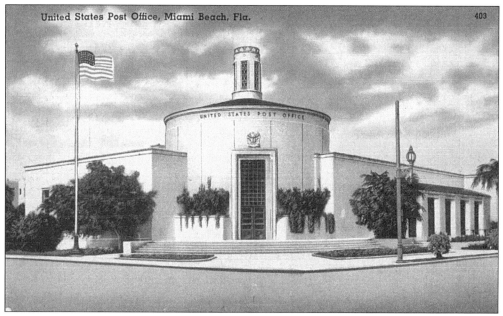

Depression Moderne combined classical elements with somewhat stark streamlining. This style grew out of the Works Progress Administration's commissioned works during the Great Depression. The Miami Beach Post Office, located at 1300 Washington Avenue, was one of those projects. Howard L. Cheney designed the South Beach landmark in 1937. (Published by Tichnor Bros.)

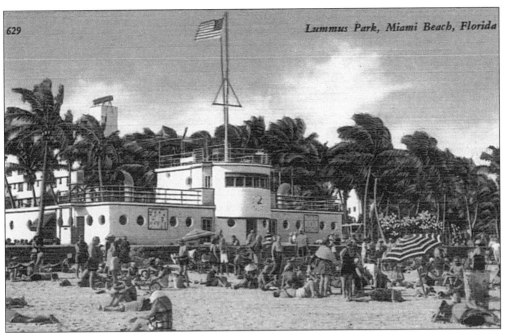

Lummus Park, Miami Beach, Florida

The Beach Patrol Headquarters at Lummus Park reflected the fascination with international travel on cruise liners with its ship-like railings, porthole windows, and top deck. It was a popular site for socializing and basking under the South Florida sun. (Published by Tichnor Bros.)

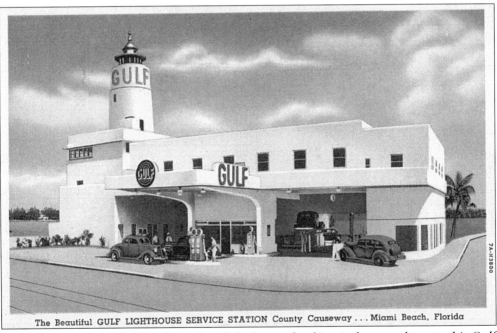

The Beautiful GULF LIGHTHOUSE SERVICE STATION County Causeway . . . Miami Beach, Florida

The nautical Deco influence brought a light-hearted, whimsical atmosphere to this Gulf Lighthouse Service Station, located on the Miami Beach side of the County Causeway. (Published by Curt Teich.)

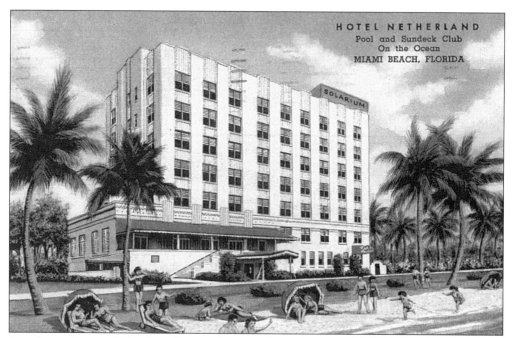

Swaying palms, pristine beaches, and tropical weather made the oceanfront the place to be. Shown above, families relax in the sun in front of the Netherlands Hotel on Ocean Drive, which was designed by E.L. Robertson in 1935. (Published by Curt Teich.)

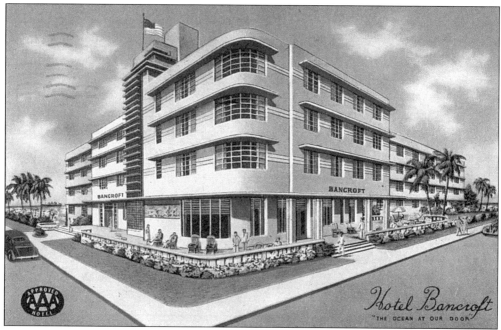

The majority of these spirited structures were built during the Deco building boom of 1934–1941. The Bancroft Hotel, at 1501 Collins Avenue, was designed by Albert Anis in 1939. The sharp angles of the vertical tower provide contrast to the horizontal racing stripes, eyebrows, and curved windows. (Published by Colourpicture.)

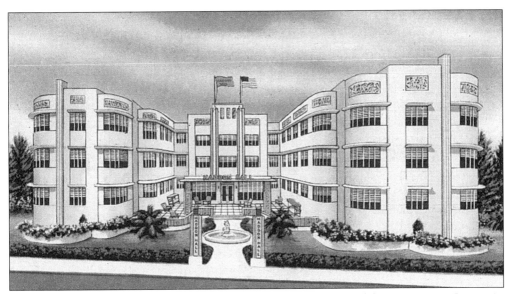

Haddon Hall, located at 1500 Collins Avenue, was designed by L. Murray Dixon in 1941. The building is divided into three parts in the classic A-B-A form in which the two symmetrical side sections offer unity while the center section provides contrast. Robert M. Schwarz was the sculptor of the beautiful cast-plaque "reliefs" along the roofline. With its sweeping curves and multitude of streamline features, Haddon Hall remains a supreme example of that style. (Published by Colourpicture.)

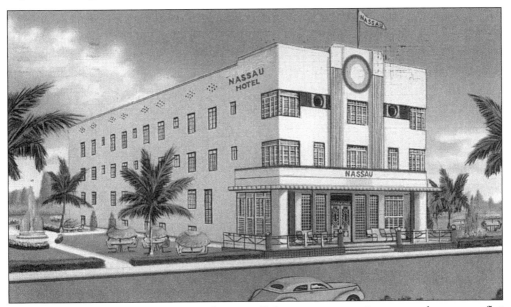

"Fluting" is the term given to the parallel grooves cut into a column or flat representation of a column called a "palister." The charming Nassau Hotel, located at 1414 Collins Avenue, has two fluted palisters on its center that rise to a parapet. Designed in 1936 as a 50-room hotel, the Nassau has recently been converted to create just 22 larger accommodations made up of spacious studios and one-bedroom units. (Published by Curt Teich.)

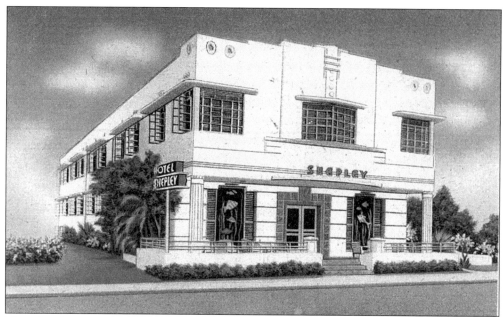

The Shepley Hotel, shown above, is located at Fourteenth Street and Collins Avenue. The back of this 1930s postcard advertised spring rates of "Five Dollars per Day, Double." (Published by Colourpicture.)

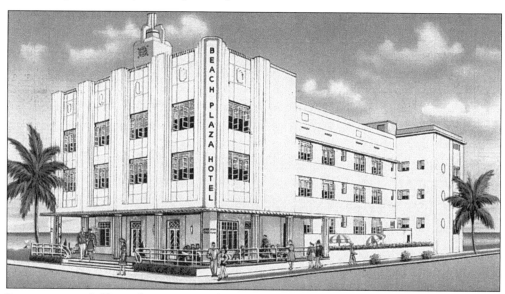

In a scene much like today, visitors relax on the porches of the Art Deco hotels. Many of the porches and lobbies have terrazzo floors. Terrazzo, made from stone chips and mortar, was used instead of marble. As a result, a stylish look was achieved for less expense. This 1939 postcard shows the Beach Plaza hotel, which is located at 1401 Collins Avenue. L. Murray Dixon designed the hotel in 1936 and created a strong upward appearance by using a series of long vertical lines between the sets of windows and a vertical sign on the corner. The rooftop tower added special interest. (Published by Curt Teich.)

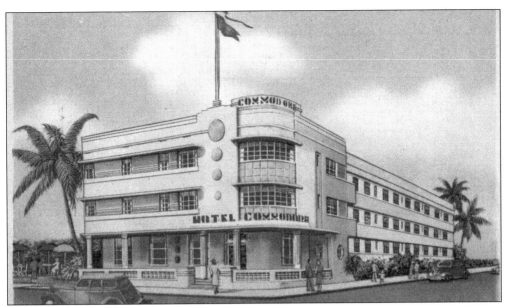

An often-used theme in architecture, the "holy three" can be seen in different ways in the Art Deco hotels of South Beach. Many of the structures are three stories tall, like the Commodore Hotel, shown above. In other instances, the building or parts of the building will be divided into three parts or architectural features will appear in "threes." Henry Hohauser designed the Commodore Hotel in 1939. The hotel, located at 1360 Collins Avenue, has graduated porthole windows and a rounded front with eyebrows over the curved windows. (Published by Colourpicture.)

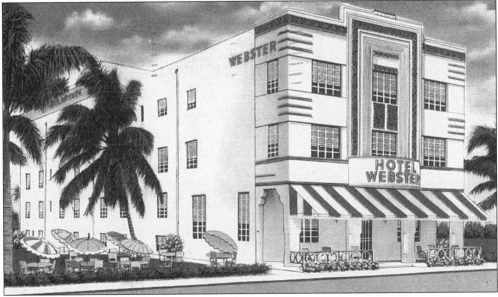

Bas reliefs are carvings or sculptures that stand out against a background surface. Examples of bas relief friezes can be seen on the front of the Hotel Webster at 1220 Collins Avenue. Henry Hohauser designed the hotel in 1936. (Published by Colourpicture.)

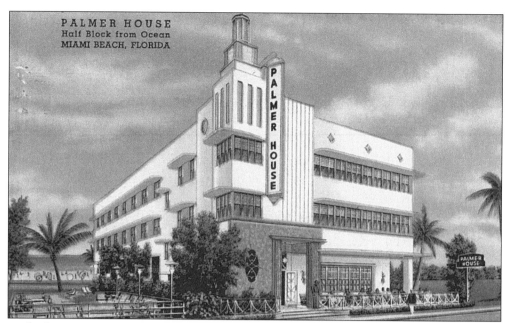

In the late 1930s, L. Murray Dixon designed the Palmer House at 1119 Collins Avenue. The hotel, with its futuristic rooftop tower, was the inspiration for the 1986 Art Deco Weekend Poster. (Published by Curt Teich.)

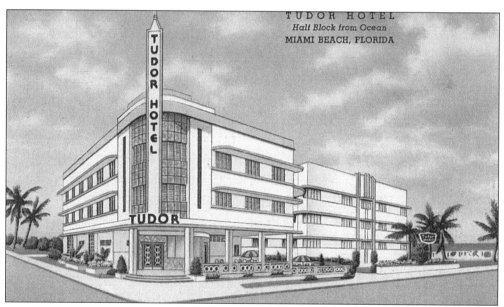

The Art Deco architects strove to give each building a unique appearance; however, the use of a central vertical element rising skyward past the roofline, creating a skyscraper effect, was a common link among the various hotels. A fine example is the vertical finial sign in front of the rounded corner entry of the Tudor Hotel. A finial is a pointed ornament (usually at the top of a parapet or vertical projection.) The hotel, located at 1111 Collins Avenue, was designed by L. Murray Dixon in 1939 and is one of South Beach's favorite settings. (Publishcd by Curt Teich.)

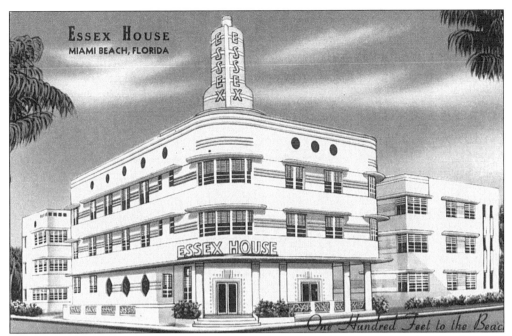

The Essex House, shown above in this 1940 postcard, is considered one of Henry Hohauser's best designs. Built in 1938 at 1001 Collins Avenue, the hotel has the streamlined shape of a ship, with porthole windows and a double-faced metal spire with neon lights that illuminate the hotel's name against the night sky. The Essex House, which received a $3-million renovation in 1998, is one of Miami Beach's most popular landmarks and tourist destinations. (Published by Colourpicture.)

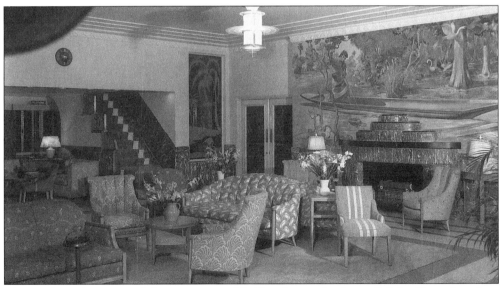

This early 1940s view of the Essex Hotel lobby shows the beautiful Art Deco fireplace and the original polychrome mural of the Everglades, which was restored by the original artist Earl LaPan, 50 years after he painted the original mural. (Courtesy of Romer Collection, Miami-Dade Public Library.)

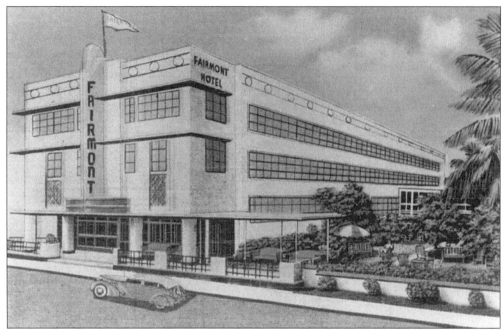

The Fairmont Hotel was designed in 1939 by L. Murray Dixon. The hotel, located at 1000 Collins Avenue, is shown in this *c.* 1940 artist rendering. The Deco classic, now named the Fairwind, remains a popular presence along Collins Avenue. (Courtesy of Historical Museum of Southern Florida.)

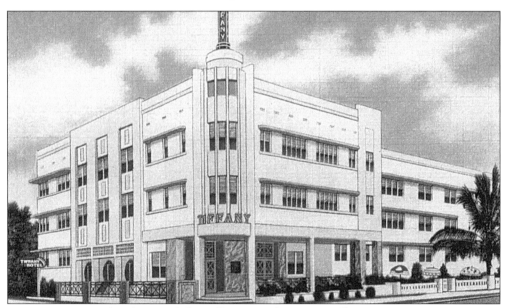

L. Murray Dixon also designed the Tiffany Hotel, at 801 Collins Avenue, in 1939. Dixon gave the rounded corner entry special interest by adding a series of vertical lines and a metal spire, which displays the hotel's name, the bottom of which can be seen in this postcard. The Tiffany was beautifully renovated and reopened as "The Hotel," a luxurious inn. (Publisher unknown.)

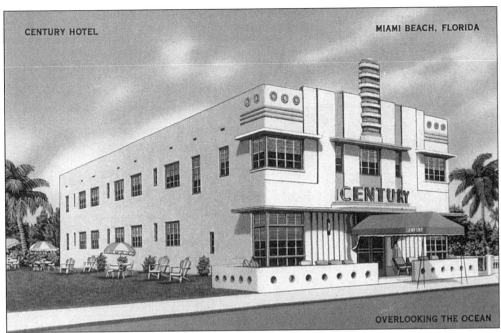

OVERLOOKING THE OCEAN

The Century Hotel is considered one of Henry Hohauser's finest works. The center vertical projection resembles an Indian totem, while the creative use of portholes along the roofline and the low-lying fence create a seaside ambience. In 1997, a total renovation of the hotel's interior was completed. The whimsical treasure, shown in this c. 1940 postcard, can be seen at 140 Ocean Drive. (Published by Colourpicture.)

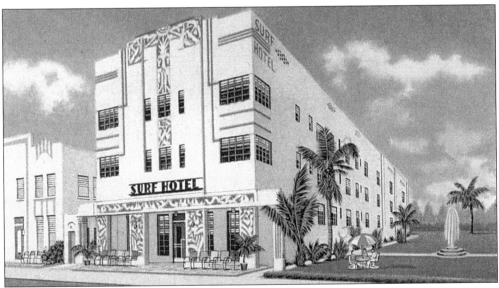

The Surf Hotel has tropical images carved into its facade The center vertical carvings that extend outward at the parapet create a totem-like image in this 1937 postcard. Today, the painting of the carvings has been reversed—what was previously light is now dark and vice versa, which creates a still pleasing but different effect. (Published by Curt Teich.)

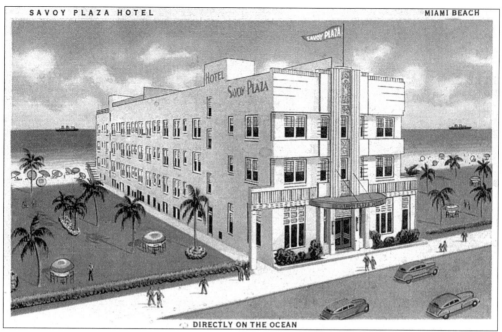

DIRECTLY ON THE OCEAN

The Savoy Plaza, located at 425 Ocean Drive, was designed by V.H. Nellenbogen in 1935. On the back of this *c.* 1936 postcard, the hotel advertised a "beach front dining room where guests can dine in their bathing suits." (Published by Colourpicture.)

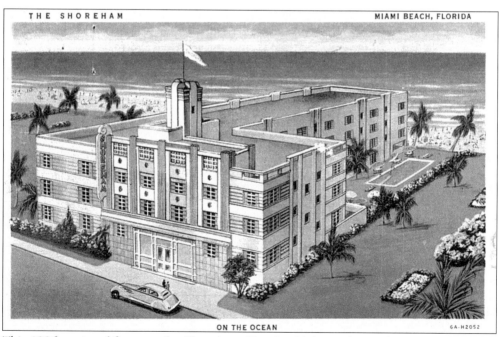

ON THE OCEAN 6A-H2052

This 1936 postcard features the Shoreham Hotel, which was located on the oceanfront at Sixth Street. Five fluted vertical columns emphasize the center front of the building and contrast sharply with the building's horizontal lines. (Published by Curt Teich.)

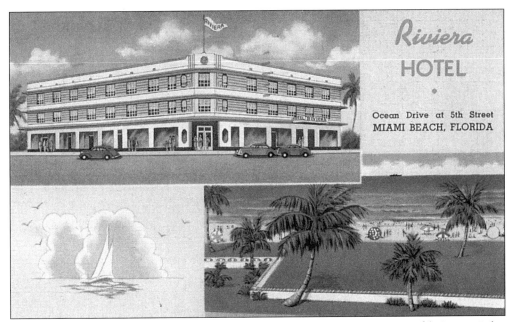

The Riviera Hotel was built in 1939 on the west side of Ocean Drive at Fifth Street. John and Carlton Skinner designed the hotel, which has an octagonal plaque displaying a carved fountain motif above the corner entry. Today, the completely restored building is occupied by the Bentley Luxury Suite Hotel. (Published by Curt Teich.)

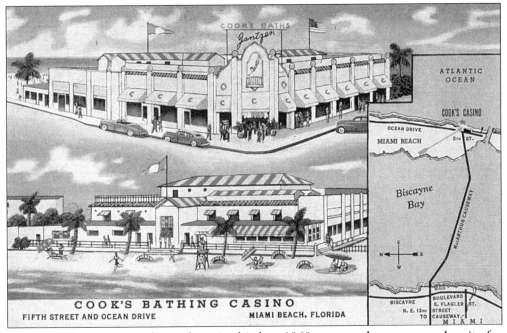

Cook's Bathing Casino, shown here in this late 1940s postcard, was a popular site for vacationers. The casino proudly advertised itself as a place where one could purchase Jantzen swimwear. (Published by Curt Teich.)

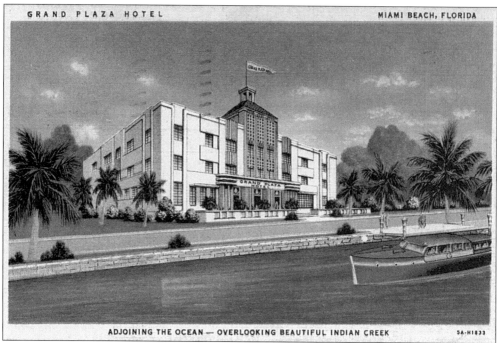

ADJOINING THE OCEAN — OVERLOOKING BEAUTIFUL INDIAN CREEK 5A-H1833

This 1935 postcard shows the Grand Plaza Hotel, which faced not on a plaza but on Indian Creek Waterway. Note the beautiful wooden "speed boat" as this kind of vessel was known at the time. The hotel itself, with its distinctive marquee, has been beautifully restored and is still in use today. (Published by Curt Teich.)

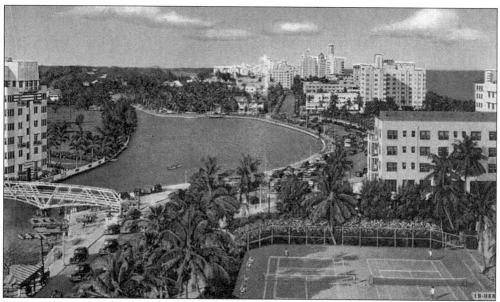

This bird's-eye view shows the Lake Pancoast area and Indian Creek Drive during the early 1940s. The Helen Mar apartment building, with its black vitrolite horizontal stripes near the top, can be seen on the left. Robert E. Collins designed the building in 1936. (Published by Curt Teich.)

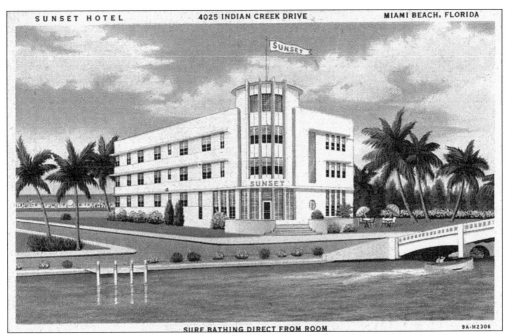

The Sunset Hotel, located at 4025 Indian Creek Drive, at the Forty-first Street Bridge, is shown on this 1939 postcard. The curved center front with vertical fins gave the hotel a distinctive appearance. (Published by Curt Teich.)

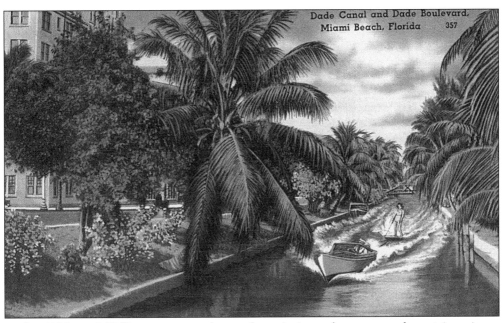

In the 1930s and 1940s, passenger air travel was in its early stages, and most Americans had never ventured very far from home. A city interlaced with canals, lined with palm trees and beautiful flowers, had a unique and rather exotic appeal. Hollywood reinforced this image with a number of films, while popular music (such as "Moon over Miami") added to this romantic image. (Published by Tichnor Bros.)

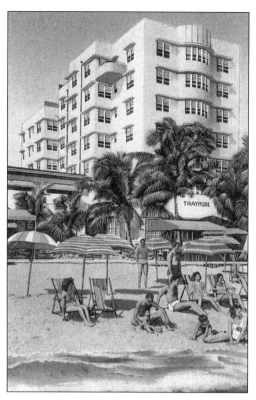

The popularity of Miami Beach continued to grow. In 1936, hotels were opening at a rate of two per week. By 1940 the census showed a year-round resident population of 28,012 and an estimated 80,000 residents living in the city during the winter season. With the tropical climate and the seemingly endless supply of recreational activities, visitors, such as the ones pictured here at the Traymore Hotel, kept flocking to the resort city. (Published by Colourpicture.)

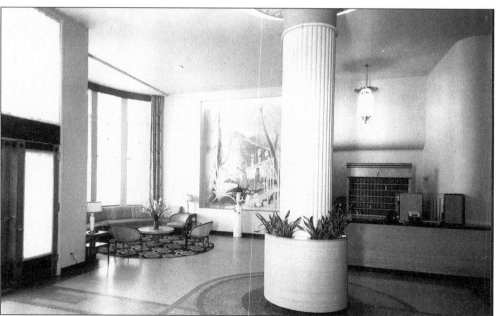

The lobby of the Traymore Hotel, as seen in this 1930s photo, clearly shows the influence of industrial designers on the Art Deco style. The furniture, light fixtures, and terrazzo floor all exhibit that sleek, streamlined effect. (Courtesy of Romer Collection, Miami-Dade Public Library.)

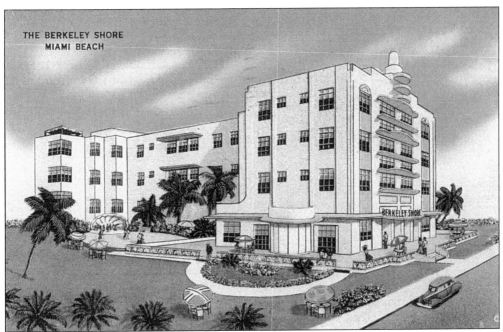

The Berkeley Shore was designed in 1940 by Albert Anis. This 1941 postcard shows a band performing in the bandshell and guests dancing on the back patio. The fanciful hotel, with its floral plaques and center totem-like vertical column, can be seen at 1610 Collins Avenue. The postcard creator took "artistic license" a bit far though because the Berkeley Shore is really only three stories tall. (Published by Colourpicture.)

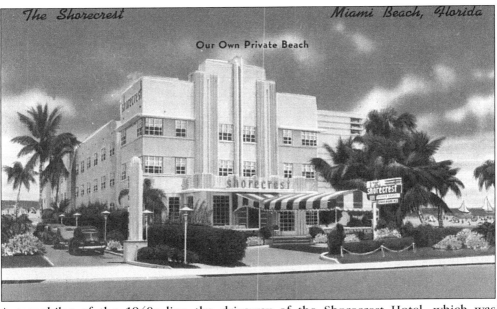

Automobiles of the 1940s line the driveway of the Shorecrest Hotel, which was located at Sixteenth Street and Collins Avenue, one block from Lincoln Road. The hotel offered its guests a private beach, an ocean lounge, cabanas, and a solarium. (Published by Colourpicture.)

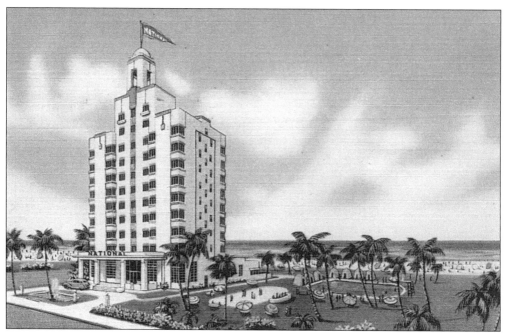

Roy F. France designed the National Hotel at 1677 Collins Avenue. When it opened in 1940, the National was one of the most luxurious hotels on Miami Beach. The fashionable and popular hotel recently underwent an award-winning restoration. (Published by Colourpicture.)

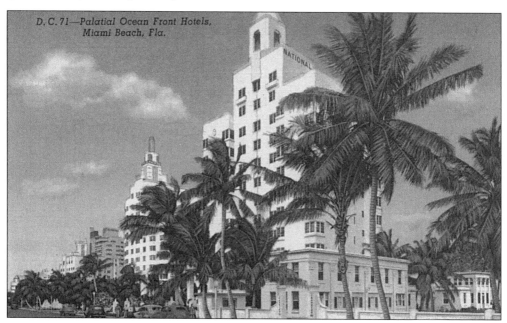

The individual hotel postcards displayed the hotels without their neighboring buildings, like the National postcard at the top of this page. A more realistic view can be seen in this early 1940s postcard, which shows the National Hotel on Collins Avenue, along with the other buildings. (Published by Curt Teich.)

The Delano, with its unmistakable winged tower, was designed in 1945 by Robert Swartburg and was the tallest building in Miami Beach at that time. The Roosevelt family kept a penthouse at the Delano for many years. Lovingly refurbished, the Delano still maintains its prominent position on Miami Beach today. (Published by Colourpicture.)

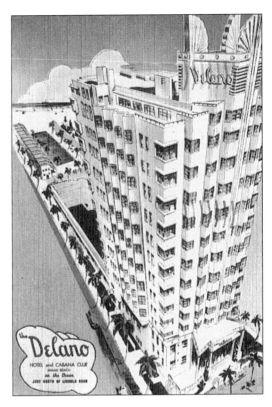

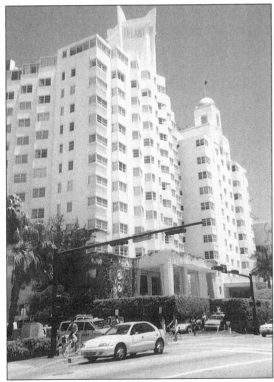

In this current photo, the Delano and National Hotels stand victoriously side by side, having survived the earlier threats of demolition that would have erased the symbols of a magical era and replaced them with buildings that could be "anywhere U.S.A." (Photo by P. Kennedy.)

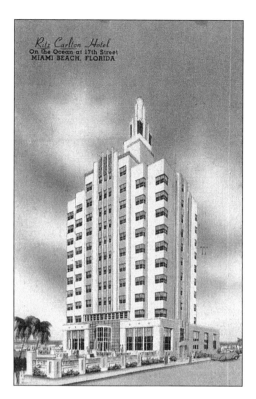

Although this early 1940s postcard says the Ritz Carlton, the majestic Art Deco tower is definitely the Ritz Plaza, designed by L. Murray Dixon in 1940. At that time, Americans were captivated with skyscrapers. These larger hotels, tall but not overwhelming, simulated the spired and towered effect of the great skyscrapers. (Published by Colourpicture.)

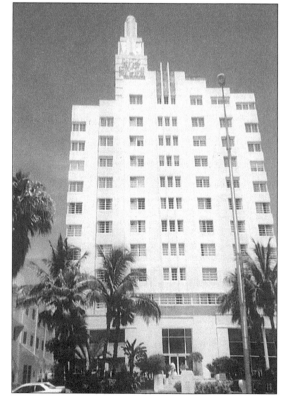

This current photo of the Ritz Plaza, shows the spectacular return of the hotel to its original splendor. Today, the Ritz Plaza, at 1701 Collins Avenue, offers the atmosphere of an earlier era with the comforts and conveniences of the 21st century. Photo by P. Kennedy.)

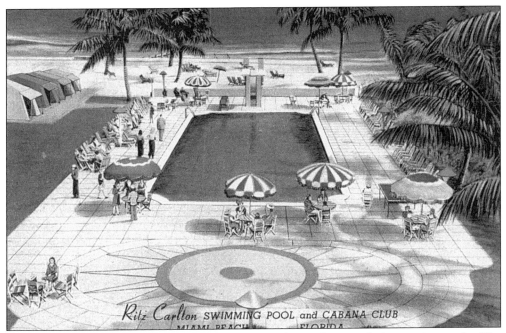

On a picture-perfect South Florida day, guests relax and enjoy their vacation at the Ritz Plaza swimming pool. (Published by Colourpicture.)

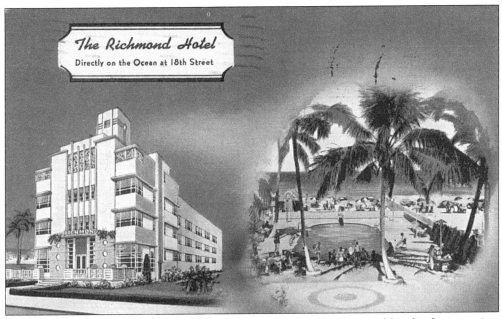

The Richmond Hotel, at 1757 Collins Avenue, is proudly operated by third generation members of the family that built the hotel in 1942. The hotel, designed by L. Murray Dixon, with its stylish entrance and nationally honored tropical garden, remains popular to this day. (Published by Colourpicture.)

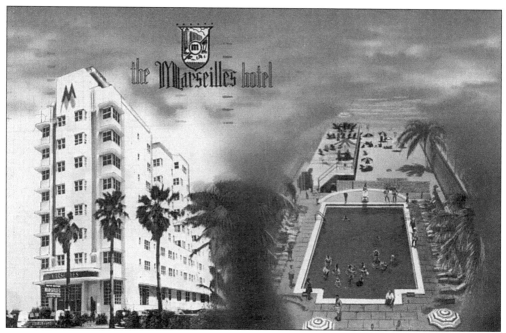

The Marseilles Hotel, located at 1741 Collins, was built in 1948 by European architect Robert Swartburg, who also designed the nearby Delano Hotel. As seen in this *c.* 1950 postcard, the hotel has a very stylish entrance. A flat overhang above the first floor with a decorative iron grill displays the hotel name in Art Deco lettering. (Published by Colourpicture.)

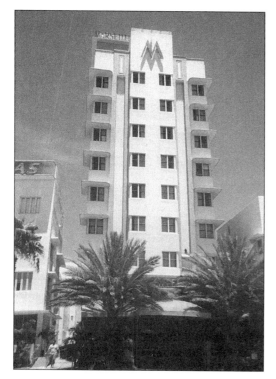

Over 50 years later, the Marseilles stands in its full glory, an elongated version of the classic three-part design, with fluted vertical columns accenting the building's middle section, a high central parapet emphasized by a large copper "M," and corner windows shaded by wraparound eyebrows. (Photo by P. Kennedy.)

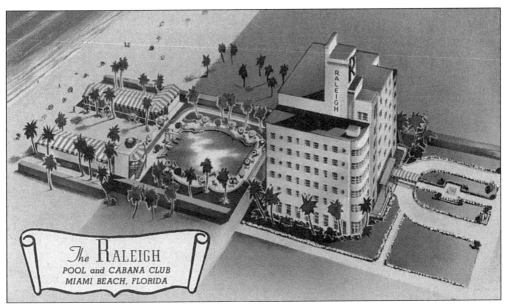

The Raleigh Hotel, at 1777 Collins Avenue, was designed by L. Murray Dixon. The opening night ball in 1940 featured Martha Raye and Desi Arnaz, an unknown local drummer who filled in and was discovered that night. The Raleigh has been featured in movies such as *The Birdcage, Bad Boys, Fairgame, Up Close and Personal*, and *The Versace Story*. (Published by Colourpicture.)

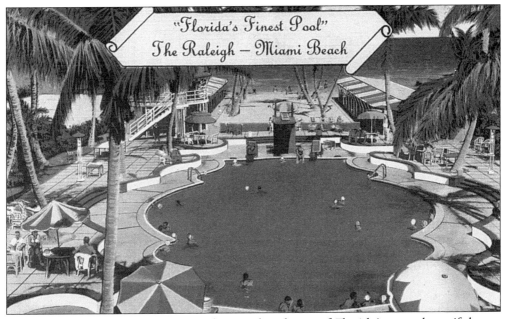

The Raleigh Hotel's swimming pool, considered one of Florida's most beautiful, was featured on the cover of *Life* magazine in the 1940s. Actress Esther Williams filmed many of her most famous swim scenes at this site. (Published by Colourpicture.)

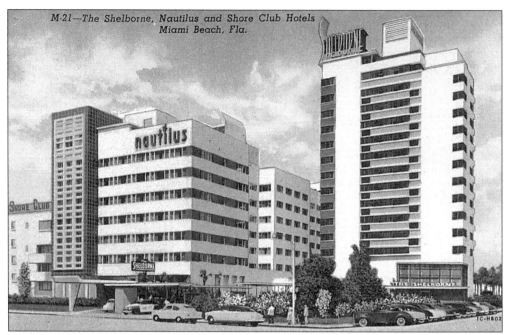

Although it was not built during the Art Deco building boom, the Shelborne Hotel (on the right) has a prominent Art Deco–style sign on the roof that clearly distinguishes the 14-story hotel. Designed by Igor B. Polevitsky, the hotel is shown in this early 1950s postcard. (Published by Curt Teich.)

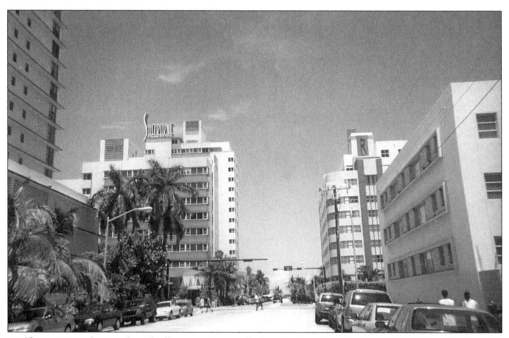

Half a century later, the Shelborne sign still dominates the skyline of Eighteenth Street, as one looks east toward the ocean. The "R" monogram of the Raleigh Hotel can also be seen on the right. (Photo by P. Kennedy.)

The St. Moritz was built in 1939 at Sixteenth Street and Collins Avenue. This 1950 postcard shows the hotel in its original heyday. Once in danger of destruction, the St. Moritz was recently restored to its splendor and combined with an adjacent 17-story tower to create the Miami Beach Loews Hotel. The $315-million partnership between the City of Miami Beach and the Loews Hotel Group created the hotel complex that includes many fashionable shops. (Published by Curt Teich.)

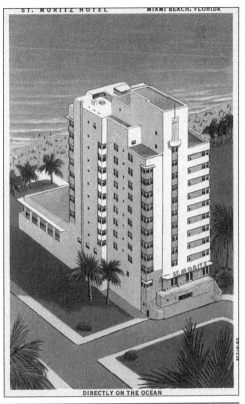

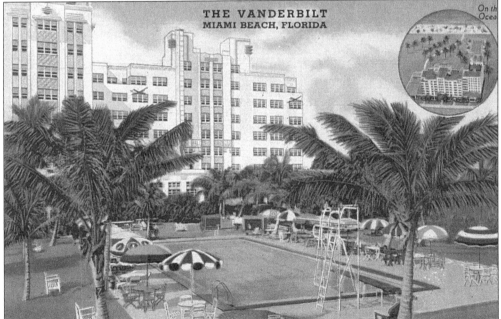

The Vanderbilt Hotel, located on the oceanfront between Twentieth and Twenty-first Streets, offered guests an inviting pool area, a solarium, and outdoor dining and dancing on the hotel patio. (Published by Curt Teich.)

L. Murray Dixon's futuristic effects on the top of his 1938 Adams Hotel were very effective, especially when combined with the sweeping eyebrows that emphasized the rounded front corner. The metal railing on the tower, suggestive of a ship's top deck, and the use of portholes shows the nautical influence. The Adams, shown on this *c.* 1940 postcard, is located on the corner of Park Avenue and Twenty-first Street. (Published by Colourpicture.)

The Barclay Plaza was designed in 1935 by architects Richard Kiehnel and John Elliott, who also designed the Carlyle Hotel on Ocean Drive. They achieved a strong horizontal feel with the use of racing stripes, which contrasted with intricately carved vertical lines at the hotel entrance. The lines rise towards a "ziggurat" (a symmetrical stairstep effect) parapet. The Barclay Plaza, shown in this 1936 postcard, is located on Park Avenue between Nineteenth and Twentieth Streets. (Published by Curt Teich.)

After many years of neglect, a major renovation of the South Beach area began in the 1980s. Today, virtually all of the Art Deco hotels have been or are being restored to their former beauty. A fine example of this is the Tyler Hotel (shown above in this current photo), which was originally designed by L. Murray Dixon in 1937. (Photo by P. Kennedy.)

Another splendid renovation restored the "Spanish Village" of Espanola Way, which was built in 1925. Today, the lovely street of graceful Mediterranean architecture is home to shops, restaurants, and the Clay Hotel. (Photo by P. Kennedy.)

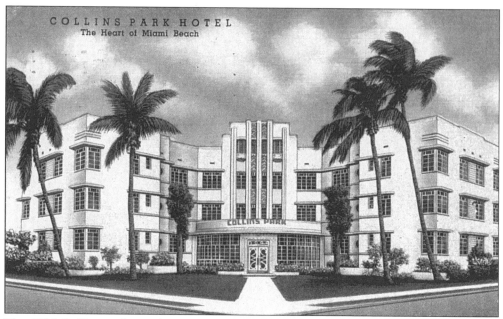

The 1939 Collins Park Hotel remains one of Henry Hohauser's great achievements. The hotel, located at 2000 Park Avenue, is named after the nearby park that was donated to the city by early pioneer John Collins. The lobby entrance and the striking, towering façade above it, contain a wealth of intricate details that make it a "must see" for any Deco enthusiast. (Published by Curt Teich.)

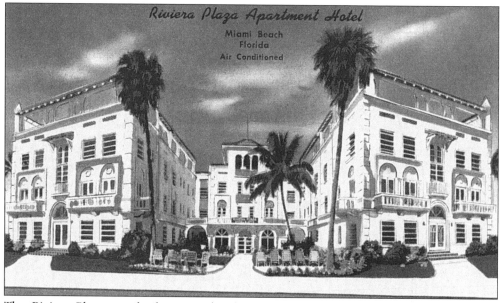

The Riviera Plaza was built in 1924, when the Mediterranean Revival style was the prevalent architectural style in the area. With its barrel roofs, arched windows, and elaborate details, the hotel exudes a graceful ambience to this day. R.A. Preas designed the apartment-hotel, which is located at 337 Twentieth Street, across from the Collins Park Hotel. (Published by Colourpicture.)

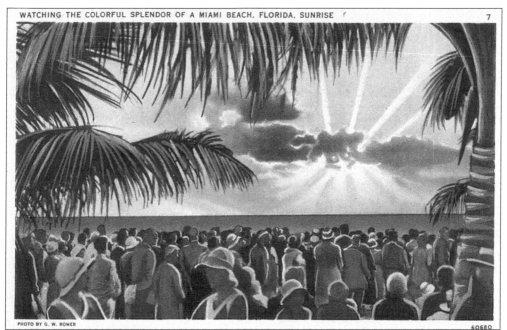

PHOTO BY G. W. ROMER 60680

During the 1930s, America and most of the world were passing through the Great Depression. Miami Beach, however, continued to grow and prosper during this period due to the tropical weather and a unique variety of tourist attractions. The spirit of optimism and pleasure can be seen in this 1935 postcard of people on Miami Beach watching the sun rise on a new day. (Published by Tichnor Bros.)

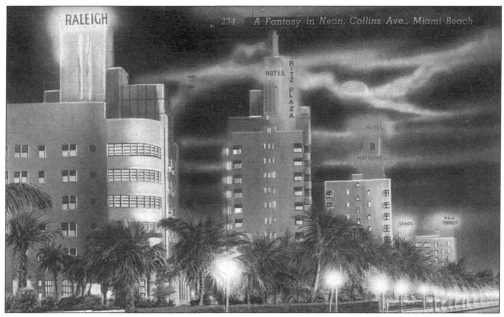

When the sun set, Miami Beach came alive with a rainbow of neon lights. Tourists, seeking to escape Northern winters, found the city a tropical fantasy at a time when life was still rather grim in much of the country. (Published by Colourpicture.)

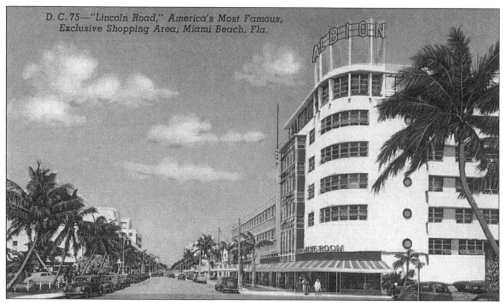

D. C. 75—"Lincoln Road," America's Most Famous, Exclusive Shopping Area, Miami Beach, Fla.

Another hotel exhibiting nautical influence is the Albion Hotel, located at 1650 James Avenue, just off historic Lincoln Road. Igor Polevitsky designed the 115-room "streamline" hotel in 1939. The Albion creates a strong nautical image with its portholes, curved front, fins that could be seen as smokestacks, and a bas relief of Neptune pointing the way to the ocean over the Lincoln Road entry. A bas relief is a carving or sculpture that extends slightly from its background surface. The striking Albion Hotel was renovated in 1997. (Published by Curt Teich.)

The Crest Hotel, located at James Avenue and Lincoln Road, is a classic Art Deco design with a flat roof decorated by metal railings and a parapet in the center, shown off by a sylish vertical sign. The fully restored hotel is now known as the Crest Suites, a popular destination for visitors. (Published by Colourpicture.)

OVERLOOKING OCEAN

6A-H1971

Sleek cars of the period pass in front of the Hotel Astor in this 1936 postcard. The hotel, designed by T. Hunter Anderson that same year, is located at 956 Washington Avenue. A lovely marquee graces the entrance as do two columns with vertical fluting. Today, the chic, intimate, 40-room hotel is one of South Beach's premiere destinations, receiving rave reviews since its reopening in 1995. (Published by Curt Teich.)

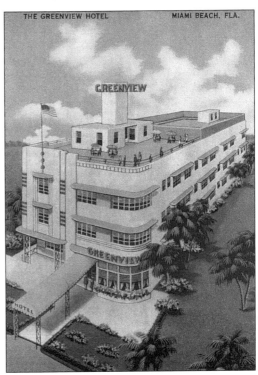

In this *c.* 1940 postcard, guests enjoy the rooftop patio at the Greenview Hotel. The metal railing around the patio, along with the rounded smokestack-like tower, create the illusion of a ship's upper deck. The Greenview is located at 1671 Washington Avenue. (Published by Colourpicture.)

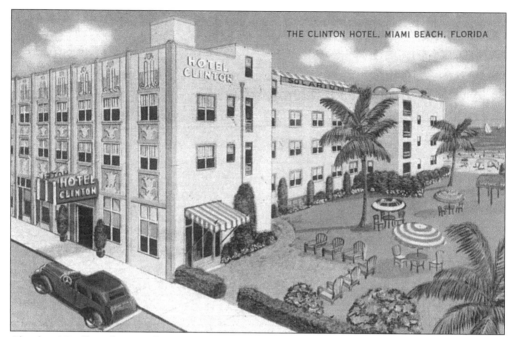

Charles Niedler designed the Clinton Hotel, located at 825 Washington Avenue, in 1934. The building was distinguished by an unusual stone marquee over the front entrance, which can still be seen today. (Published by Colourpicture.)

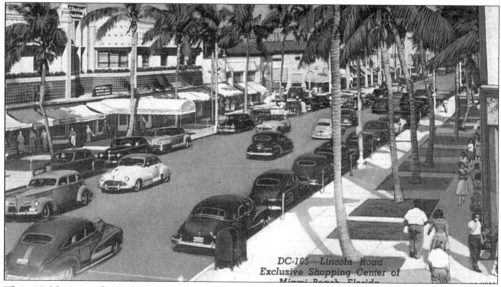

This 1946 view of Lincoln Road shows the Sterling Building on the left. Over the last 70 years, the Sterling Building, located at 978 Lincoln, has changed with the times. Originally designed as two Mediterranean-style buildings in 1928 by Alexander Lewis, the building was recreated into a streamlined Art Deco building in 1941 by V.H. Nellenbogen, who connected the two former buildings at the second floor and used blue tiles and glass blocks to create the smooth, graceful appearance. In 1986, the Sterling was meticulously restored. (Published by Curt Teich.)

This late 1940s postcard shows the back of the Versailles Hotel, which faces the ocean. The symmetrical rows of curved windows graduate towards the center of the building, resulting in smooth vertical lines. (Published by Curt Teich.)

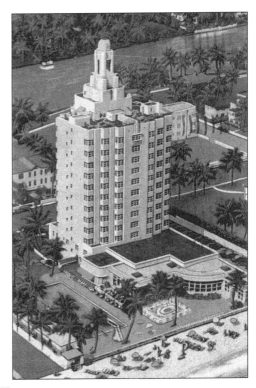

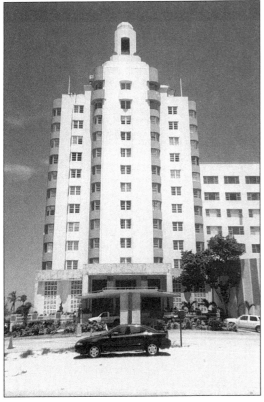

This current photo shows the front of the same building as it appears today. The effective use of color emphasizes the long vertical rows of curved windows. The ultramodern tower on the roof is topped with a cupola. (Photo by P. Kennedy.)

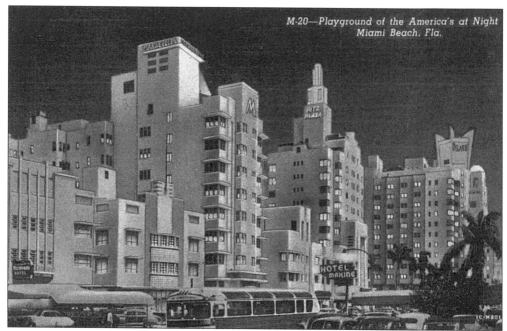

In the 1940s Las Vegas was still in its infancy while Miami Beach was ablaze with neon lights that created a wonderland of color at night. (Published by Curt Teich.)

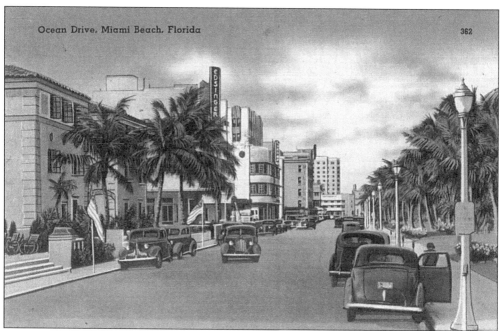

Ocean Drive, Miami Beach, Florida 362

South Beach's famous Ocean Drive is pictured here in the late 1930s. Ocean Drive is the location of the annual Art Deco Festival, held each January by the Miami Design Preservation League, whose dedicated members fought hard to preserve the architectural treasures enjoyed by all today. (Published by Tichnor Bros.)

The New Yorker was a shining example of the creative use of many classic Art Deco features. The beautiful symmetry, both horizontal and vertical, the wraparound sunshade eyebrow of the ground and highest floor, the rounded marquee over the entrance, its three-part harmony, the vertical glass-block strips, and the stepped parapet with fluted molding all resulted in a masterpiece that unfortunately was demolished in the name of progress. (Published by Curt Teich.)

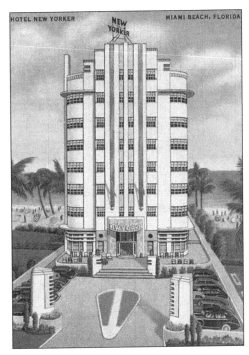

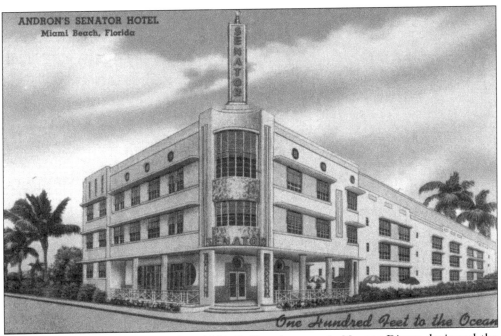

The Senator Hotel was located at 1201 Collins Avenue. L. Murray Dixon designed the streamline classic in 1939. The hotel had tropical scenes etched into the glass windows and portholes. The rounded corner entrance had corner lantern windows and a finial spire that projected its name towards the sky. Despite a valiant effort by preservationists to save it, the architectural treasure was demolished in 1988 to make a parking lot. (Published by Colourpicture.)

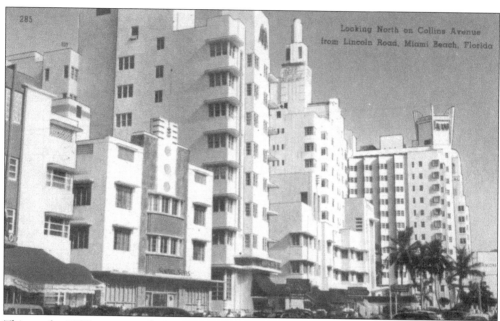

This early 1950s postcard shows a view of Collins Avenue looking south (not north as stated on the card). The impressive lineup of Art Deco hotels reads, from north to south, as follows: the Richmond, the South Seas, the Marseilles, the Del Caribe, the Ritz Plaza, the Surfcomber, the Delano, and a small view of the National. (Published by Colourpicture.)

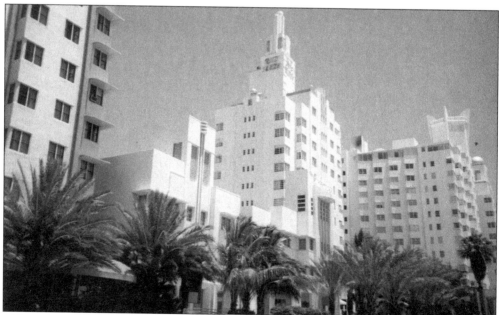

Although many important structures have been lost, the renovation of almost the entire historic district is one of the most successful preservation projects in the country. In this current photo (showing nearly the same view as the one above), it is obvious that the Art Deco District is unlike any other place in the world.

Four

SCENES ABOUT TOWN

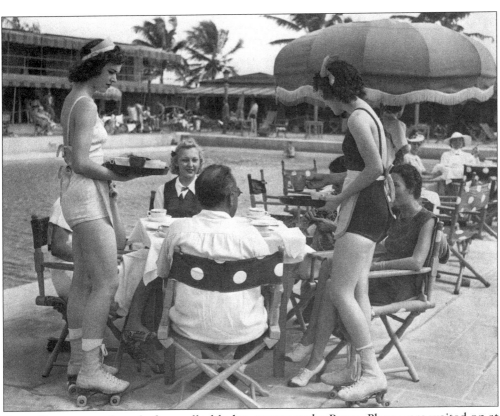

Over 60 years ago, long before rollerblades, guests at the Roney Plaza were waited on at poolside by waitresses on rollerskates, as shown in this 1939 photo. (Courtesy of Florida State Archives.)

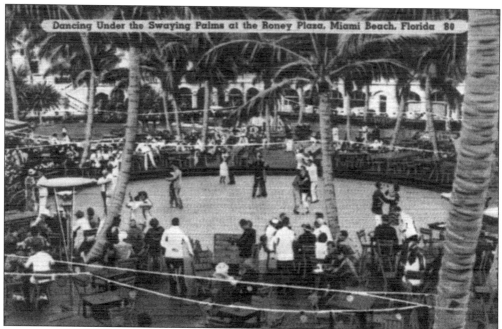

Guests at the Roney Plaza Hotel dance to "Moon over Miami" under the swaying palms, taking advantage of the tropical climate. (Published by Tichnor Bros.)

Monsignor William Barry led the parish of St. Patrick's Catholic Church as it celebrated its first Mass in 1926 at the Miami Beach Garden Theater. By June 2, 1926, Masses were held in refurbished polo stables that Carl Fisher had donated for the church and school. Within three months, the stables were devastated by the Great Hurricane of 1926, but were repaired and used until 1928, when the parish built the church shown on this 1937 postcard. The church is located at 3700 Garden Avenue and is used by the parish to this day. (Published by Curt Teich.)

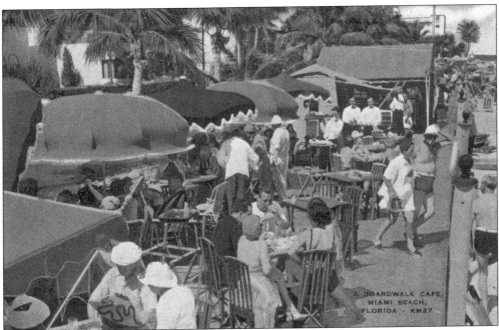

By the 1940s, Miami Beach was a booming tourist destination, with the beaches full and popular cafes crowding the boardwalk. (Published by E.C. Kropp.)

Efforts to develop an appealing image of Miami Beach and promote tourism frequently included a group of attractive young women posed in identical bathing suits. (Published by Tichnor Bros.)

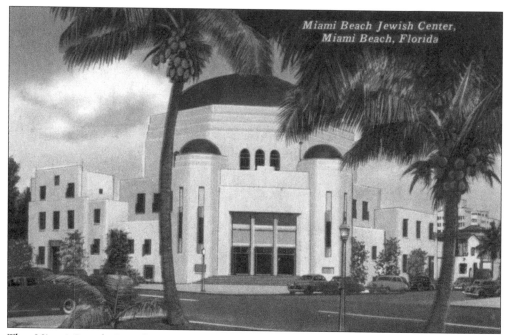

The Miami Beach Jewish Center on Washington Avenue was built in the 1940s and changed its name to Temple Emanu-El, meaning "May God Be With Us" in 1954. This postcard shows the Center as it appeared in the 1940s. (Published by Curt Teich.)

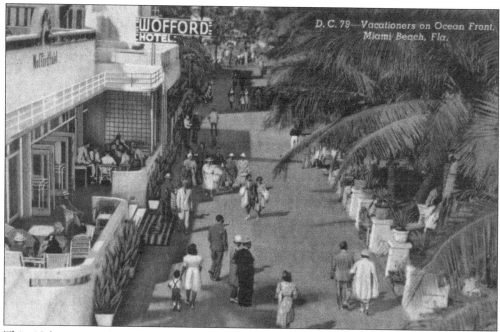

This 1941 postcard shows that the Wofford Hotel had been remodeled to incorporate elements of the popular Art Deco style. Vacationers stroll along the oceanfront, blissfully unaware of the war about to begin. (Published by Curt Teich.)

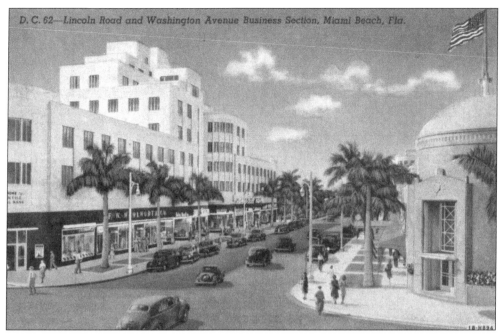

The Depression Moderne–style Miami Beach Post Office, located on the corner of Lincoln Road and Washington Avenue, is shown at the right on this 1941 postcard. The postcard's sender writes that "Lincoln Road is a nice shopping section-many New York City names." (Published by Curt Teich.)

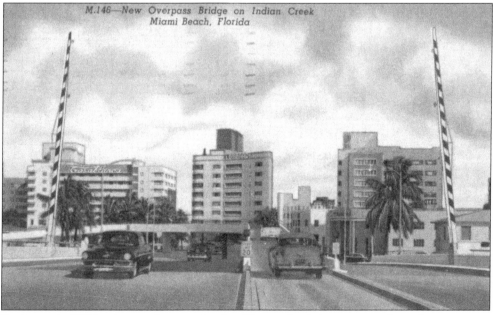

By the early 1950s, the steady growth of traffic required the construction of an overpass at Sixty-third Street near Collins Avenue. (Published by Curt Teich.)

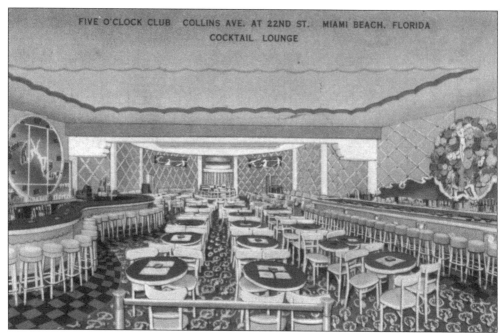

The Five O'Clock Club was so named because a pre-dinner cocktail was very much a part of the daily routine for many visitors vacationing in Miami Beach. The number of stools would indicate how well attended the bar was during cocktail hour. (Published by Colourpicture.)

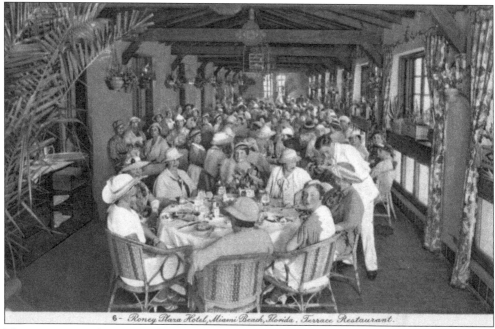

There was no shortage of "Ladies Who Lunch" at this successful luncheon at the Roney Plaza's Terrace Restaurant, as this 1930s postcard will attest. (Published by K.S. Tanner Jr.)

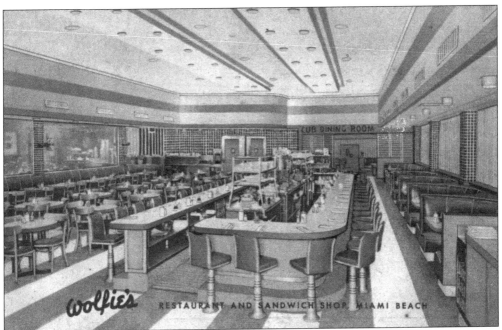

Wolfie's Restaurant, Miami Beach's most famous delicatessen, has welcomed customers since 1947. The landmark is located at 2038 Collins Avenue. (Published by Curt Teich.)

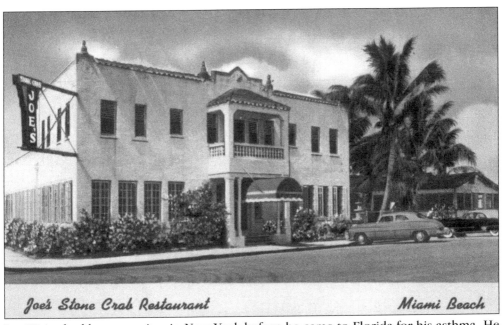

Joe Weiss had been a waiter in New York before he came to Florida for his asthma. He opened a sandwich counter at Smith's casino in 1913 and later opened a restaurant. In the early 1920s, he learned that by boiling, then chilling the stone crab, the iodine taste was removed. By the 1930s, his Joe's Stone Crab Restaurant was boiling, chilling, cracking, and icing 3,000 pounds of stone crab daily. The restaurant is one of the oldest landmarks in Miami Beach. (Published by Colourpicture.)

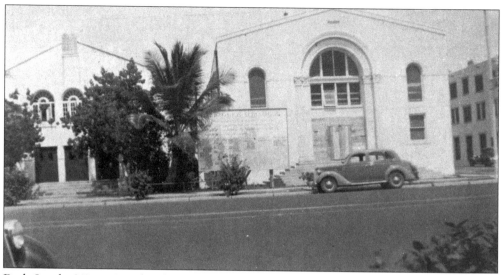

Beth Jacob, Miami Beach's first Jewish congregation, was formed in 1925. It had the first Hebrew school and, by the 1930s, was an essential part of the city. The synagogue (shown above), at 301 Washington Avenue, was built in 1936 as the second synagogue for Beth Jacob and is on the National Register of Historic Places. Designed by prominent Art Deco architect Henry Hohauser, the synagogue is now the site of the Jewish Museum of Florida. (Courtesy of Jewish Museum of Florida.)

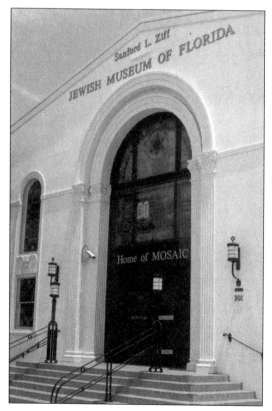

The former Beth Jacob synagogue reopened in 1995 as the site of the Sanford L. Ziff Jewish Museum of South Florida. The museum houses the "MOSAIC" collection, the permanent exhibition of "Jewish Life in Florida." (Courtesy of Jewish Museum of Florida.).

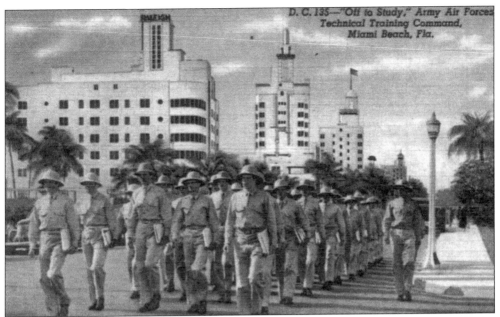

Miami Beach served as a center for officer training during World War II, and most of the hotels became barracks for the trainees. By the end of the war, one-fourth of the officers and one-fifth of the enlisted men in the United States Army Air Corps had trained in Miami Beach. After experiencing the tropical atmosphere, many servicemen eventually relocated to South Florida. (Published by Curt Teich.)

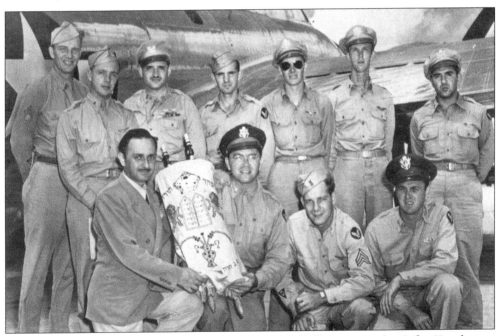

In this May 1944 photograph, Rabbi Moses Mescheloff presents the Sefer Torah to a member of the Air Force on behalf of the congregation of Temple Beth Jacob. (Courtesy of Florida State Archives.)

The Collins Library, located at 2121 Park Avenue on land donated by John Collins, was designed in 1930 by Russell T. Pancoast, Collins's grandson. The building was home to the Miami Beach Public Library and Art Center until 1963, when the city built a larger library in front of this one. Philanthropists John and Johanna Bass donated the money for the renovation and for a multi-million dollar art collection to be housed inside the former library, which is now the Bass Museum of Art. (Courtesy of Florida State Archives.)

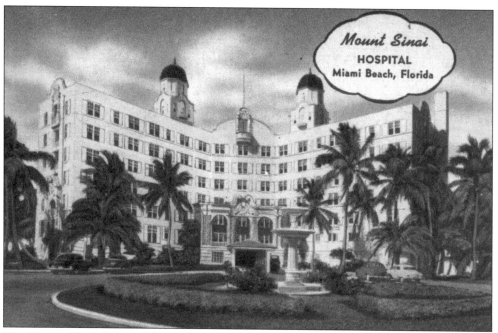

The Mount Sinai Hospital first offered its services in December 1949 at the old Nautilus Hotel. It was the first hospital to welcome everyone, regardless of race, religion, or national origin. (Published by Colourpicture.)

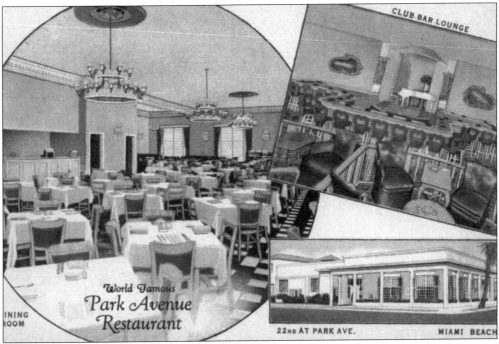

The Park Avenue Restaurant and "Fan and Bills" were typical of the many restaurants that sprang up to serve the growing number of visitors to Miami Beach. Menus frequently featured local seafood specialties, tropical fruits, and Key lime pie. (Published by Curt Teich and Colourpicture.)

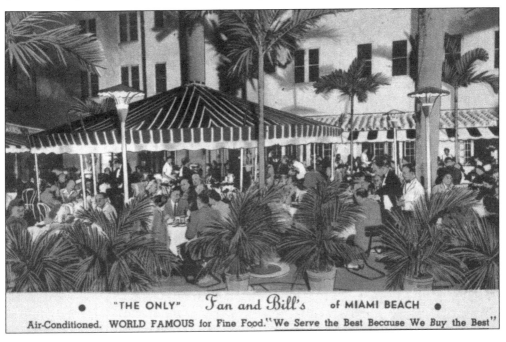

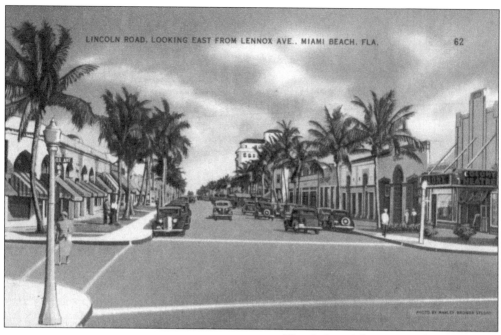

MONTE CARLO HOTEL
ON THE OCEAN — FULLY AIR-CONDITIONED
MIAMI BEACH, FLORIDA

The Colony Theater can be seen in this early view of Lincoln Road. The theater, located at 1040 Lincoln Road, was built by Paramount and designed by R.A. Benjamin in 1934. In 1976, the Colony Theater reopened after being meticulously restored by prominent architect Morris Lapidus. (Published by Tichnor Bros.)

As Miami Beach developed, no new, large hotel could be considered complete without a prominent swimming pool, which was invariably the center of daytime activity. Shown above, guests enjoy the vacation atmosphere at the Monte Carlo Hotel. (Published by Curt Teich.)

This view, looking south towards the 3200 block of Collins Avenue, shows the Richter and Saxony Hotels, which were two of the largest hotels existing at the time of this 1939 postcard. (Published by Curt Teich.)

The Normandy Plaza Hotel, located at 6979 Collins Avenue, was built in 1936. Shown in this 1939 postcard, the charming hotel has two beautifully sculptured vertical panels rising to the center parapet and Art Deco lettering above the entrance. (Published by Curt Teich.)

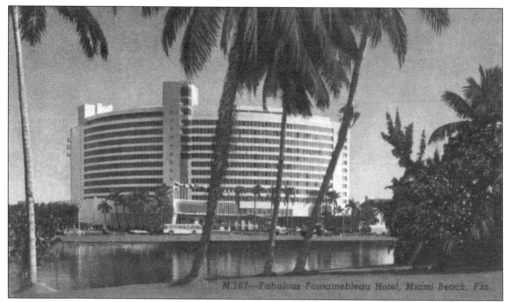

Ben Novack opened the Fontainebleau, Miami Beach's largest and grandest hotel, in December 1954 on the former site of the Firestone mansion. Architect Morris Lapidus designed the $15-million hotel in the shape of a sweeping curve. In 1977, Stephen Muss and the Hilton Hotels took over the hotel, one of the premiere Miami Beach destinations. (Published by Colourpicture.)

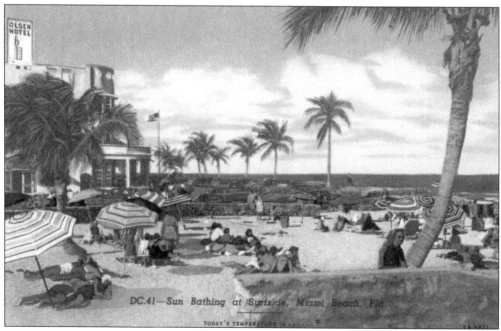

This 1945 postcard shows sunbathers relaxing on the beach near the Olsen Hotel in the Surfside district of Miami Beach. The Olsen Hotel was located at 7300 Ocean Terrace, which is a two-block stretch of oceanfront road between Seventy-third and Seventy-fifth Streets, away from the busy thoroughfare. (Published by Curt Teich.)

Prominent architect Anton Skislewicz designed the Ocean Surf Hotel, shown here in the late 1940s. The Ocean Surf is located on Ocean Terrace and Seventy-fifth Street. The area was originally known as the Harding Townsite Oceanside District, which was promoted as a secluded postwar tropical resort. The Harding Townsite was designated a historic district in 1996 by the city of Miami Beach. (Published by Curt Teich.)

Shown today, the Ocean Surf Hotel has retained its Art Deco charm. The hotel re-opened on February 14, 1997 after a year-long restoration project. (Photo by P. Kennedy.)

121

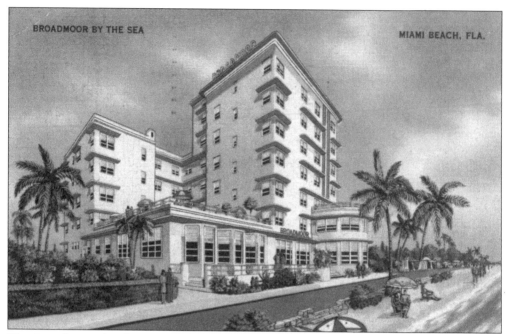

The Broadmoor by the Sea was built next to the Ocean Surf Hotel on Ocean Terrace and Seventy-fifth Street. The small collection of hotels offered a peaceful and relaxing oceanfront vacation. (Published by Colourpicture.)

The old meets the new in this current photograph, showing, in the foreground, the fully restored former Broadmoor by the Sea (now the Days Inn), followed by the Ocean Surf , and a new highrise in the distance. The immaculately maintained Ocean Terrace still provides a peaceful, secluded atmosphere. (Photo by P. Kennedy.)

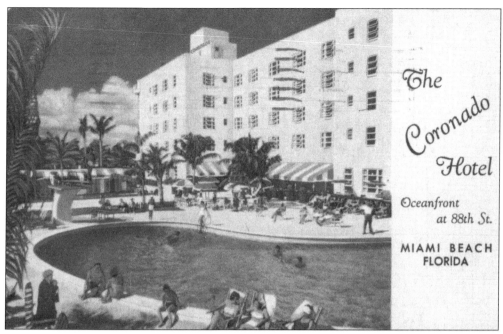

As World War II ended, expansion activity renewed in Miami Beach. One of the first hotels built following the end of the war was the Coronado Hotel, located on the oceanfront at Eighty-eighth Street. (Published by Curt Teich.)

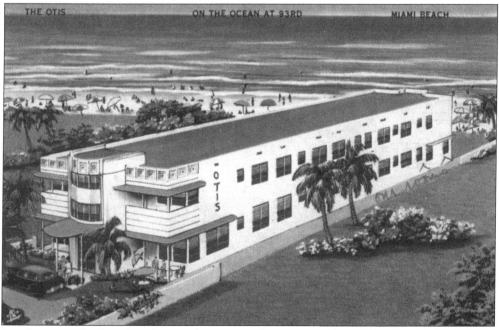

Another popular hotel in the northern part of Miami Beach was the Otis Hotel, located on the oceanfront at Ninety-third Street. The hotel offered a choice of rooms or villas and a private beach and was built with stylish Art Deco features. (Published by Colourpicture.)

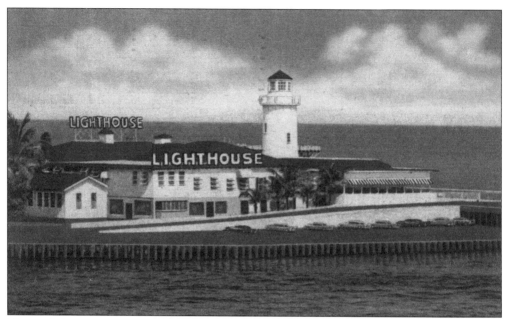

The Lighthouse restaurant was located on the oceanside in Bal Harbour just south of Baker's Haulover Bridge. The popular restaurant specialized in seafood and had a large enough clientele to remain open year round. Today the site is occupied by the Harbour House Apartments. (Published by Curt Teich.)

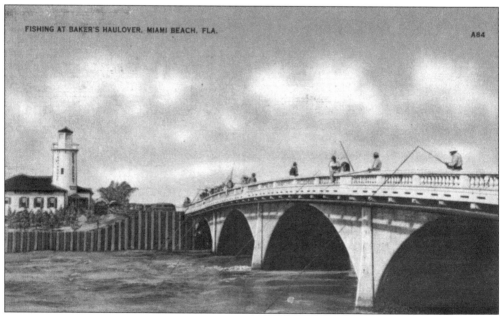

Miami Beach is a fisherman's paradise with an endless array of fishing spots. The Bakers Haulover Bridge, shown above, was a favorite spot of many. The channel itself was cut in 1917 and opened the north end of Biscayne Bay to the Atlantic Ocean. Previously, Miami Beach had actually been a peninsula, and the opening of the channel made it an island. (Published by Colourpicture.)

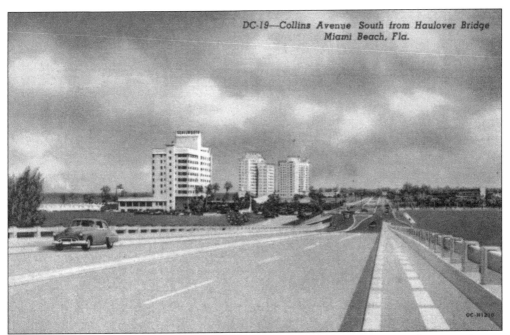

This postcard, produced in 1950, shows Collins Avenue from the Haulover Bridge in Bal Harbour. The closest buildings to the bridge are the Kenilworth and the Seaview Hotels. (Published by Curt Teich.)

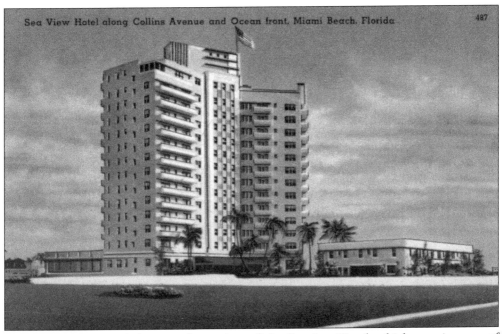

This *c.* 1945 postcard shows a closer view of the Seaview Hotel, which remains one of the most popular hotels in Bal Harbour. (Published by Tichnor Bros.)

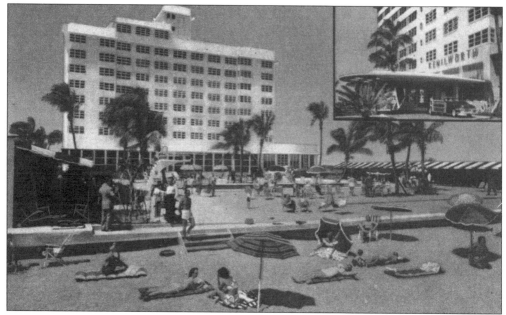

Guests enjoy the sunshine and socialize on the beach behind the Kenilworth Hotel in this 1947 postcard. The Kenilworth was located at 102nd Street in Bal Harbour. Arthur Godfrey broadcast his nationwide show from the Kenilworth, and a major thoroughfare in Miami Beach is named in his honor. (Published by Curt Teich.)

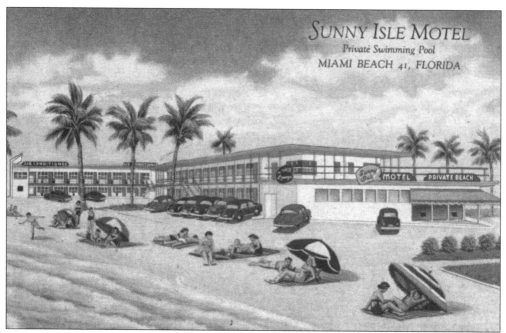

The Sunny Isle Motel at 16525 Collins Avenue offered its guests a private swimming pool as well as the beach. The motel was located north of the Haulover Bridge in the Sunny Isles district, which is north of Bal Harbour. (Published by Curt Teich.)

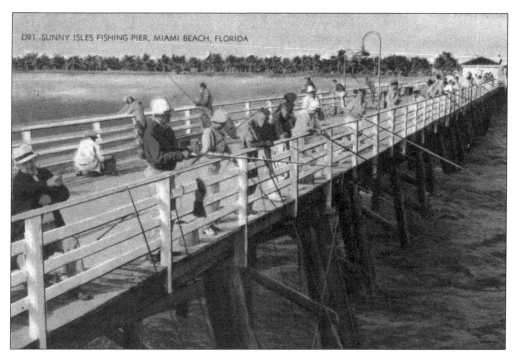

D91 SUNNY ISLES FISHING PIER, MIAMI BEACH, FLORIDA

Whether it was dining in the many restaurants, going to the races, strolling on the boardwalk, fishing from the pier, or sunbathing on the beach, it was "Great to be in Miami Beach." (Published by Curt Teich.)

M.154

Gee! It's Great to be in Miami Beach, Fla.

BIBLIOGRAPHY

Bodek, Ralph. *Miami Poppycock*. Miami: Hallmark Press, 1994.

Capitman, Barbara Baer. *Deco Delights: Preserving the Beauty and Joy of Miami Beach Architecture*. New York: E.P. Dutton, 1988.

Cerwinske, Laura. *Tropical Deco: The Architecture and Design of Old Miami Beach*. New York: Rizzoli International Pub. Inc., 1981.

Kleinberg, Howard. *Miami: The Way We Were*. The Miami Daily News, Inc., 1985.

Parks, Arva Moore, and Gregory W. Bush. *Miami: The American Crossroad, A Centennial Journey*. Needham Heights, Massachusetts: Simon and Schuster, 1996.

Redford, Polly. *Billion-Dollar Sandbar: A Biography of Miami Beach*. New York: E.P. Dutton & Co. Inc., 1970.

Root, Keith. *Miami Beach Art Deco Guide*. Miami Beach: Miami Design Preservation League, 1987.

Smiley, Nixon. *Yesterday's Miami*. Miami: E.A. Seemann Pub. Inc., 1973.